# PHOTOSECRETS
# LISBON

## A PHOTOGRAPHER'S GUIDE

BY
ANDREW HUDSON

*"A good photograph
is knowing where to stand."*
*— Ansel Adams*

# 📣 Acclaim for PhotoSecrets

🏆 Grand Prize in the National Self-Published Book Awards

🏆 Benjamin Franklin Award for Best First Book

🏆 Best Travel Guide, Benjamin Franklin Awards finalist

*"Impressive in its presentation and abundance of material."*
— *National Geographic Traveler*

*"PhotoSecrets books are an invaluable resource for photographers."*
— *Nikon School of Photography*

*"One of the best travel photography books we've ever seen."*
— *Minolta*

*"Guides you to the most visually distinctive places to explore with your camera."*
— *Outdoor Photographer*

*"This could be one of the most needed travel books ever published!"*
— *San Francisco Bay Guardian*

*"The most useful travel guides for anyone with a camera."*
— *Shutterbug's Outdoor and Nature Photography*

*"Takes the guesswork out of shooting."*
— *American Way (American Airlines magazine)*

# 📷 Gallery

## Morning

## Afternoon

## Sunset

## Dusk

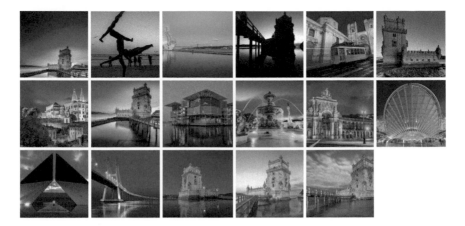

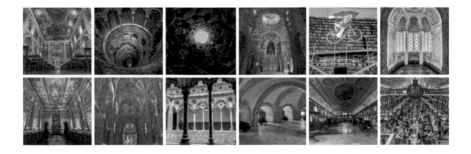

## Night

## Indoors

# © Copyright

**PhotoSecrets Lisbon**, first published November 6, 2018. This version output September 28, 2018.

ISBN: 978-1-930495-18-0. Distributed by National Book Network. To order, call 800-462-6420 or email customercare@nbnbooks.com.

Curated, coded and designed by Andrew Hudson. Copyright © 2018 Andrew Hudson for PhotoSecrets, Inc. Photos, text and maps copyrights are listed in the credits section.

> *"'And what is the use of a book,' thought Alice*
> *'without pictures or conversations?'"*
> *— Alice's Adventures in Wonderland, Lewis Carroll*

## © Copyright

All rights reserved. No part of this publication may be reproduced, stored, or transmitted in any way without the prior written permission of both the copyright owner(s) and the publisher of this book.

## ⚖ Disclaimer

The information provided within this book is for general informational purposes only. Some information may be inadvertently incorrect, or may be incorrect in the source material, or may have changed since publication, this includes GPS coordinates, addresses, location titles, descriptions, Web links, and photo credits. Use with caution; do not photograph from roads or other dangerous places or when trespassing, even if GPS coordinates and/or maps indicate so; beware of moving vehicles; obey laws. The publisher and author cannot accept responsibility for any consequences arising from the use of this book. There are no representations or warranties about the completeness or accuracy of any information contained in this book for any purpose. Any use of this information is at your own risk. Enjoy!

## ✉ Contact

For corrections, please send an email to andrew@photosecrets.com. Instagram: photosecretsguides; Web: www.photosecrets.com

# Table of Contents

# 📍 Maps

## 📍 Lisbon

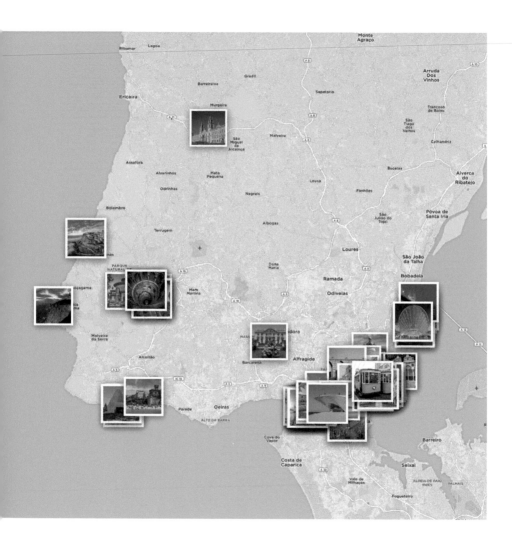

# 📍 City of Lisbon

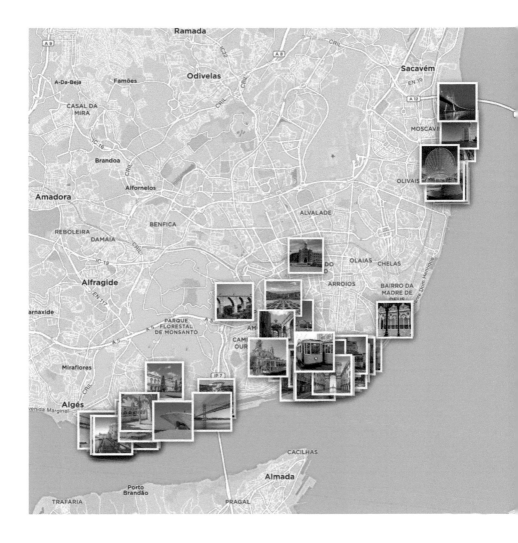

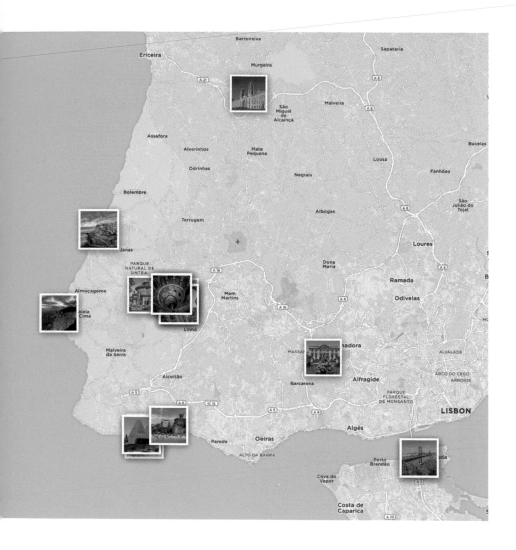

# 📍 Belém

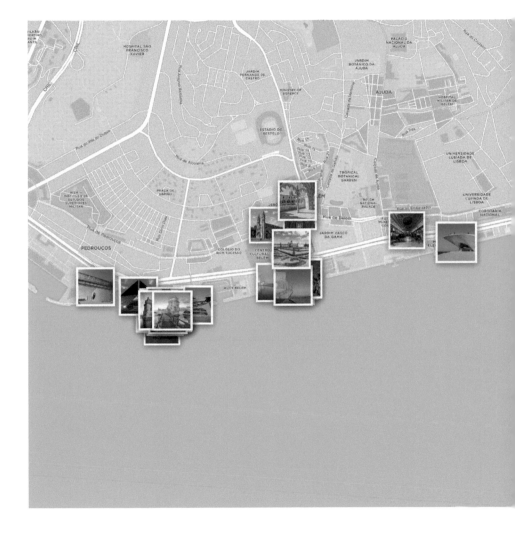

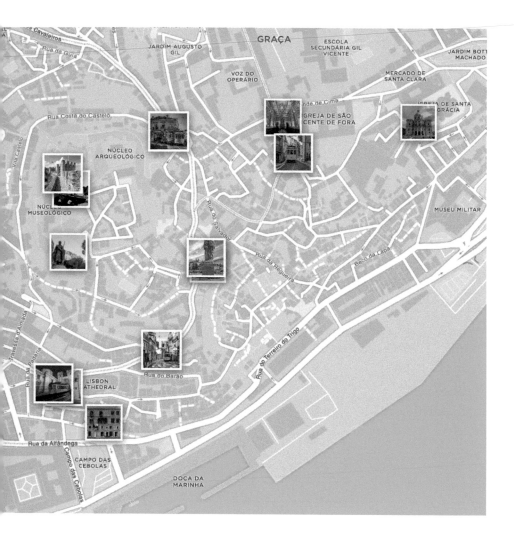

# 📍 Nations Park

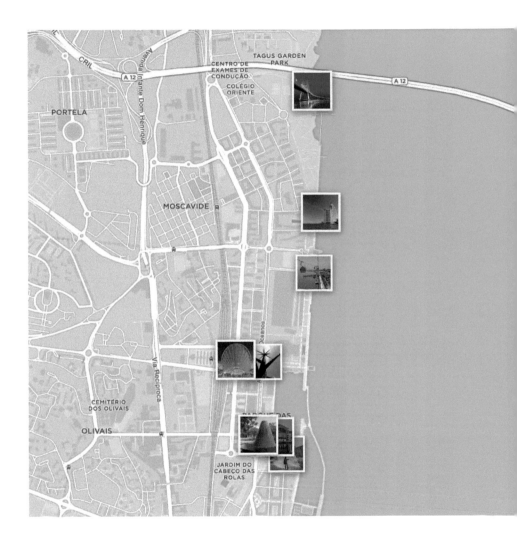

# ☺ About PhotoSecrets

👍 Founded in 1995.
👍 First color travel photo guides (1997).
👍 15 color photography books published.

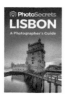    

## Coming soon:

**A GREAT TRAVEL** photograph, like a great news photograph, requires you to be in the right place at the right time to capture that special moment. Professional photographers have a short-hand phrase for this: "F8 and be there."

There are countless books that can help you with photographic technique, the "F8" portion of that equation. But until now, there's been little help for the other, more critical portion of that equation, the "be there" part. To find the right spot, you had to expend lots of time and shoe leather to wander around, track down every potential viewpoint, and essentially re-invent the wheel.

In my career as a professional travel photographer, well over half my time on location is spent seeking out the good angles. Andrew Hudson's PhotoSecrets does all that legwork for you, so you can spend your time photographing instead of wandering about. It's like having a professional location scout in your camera bag. I wish I had one of these books for every city I photograph on assignment.

PhotoSecrets can help you capture the most beautiful sights with a minimum of hassle and a maximum of enjoyment. So grab your camera, find your favorite PhotoSecrets spots, and "be there!"

*Bob Krist*

---

**Bob Krist** has photographed assignments for *National Geographic, National Geographic Traveler, Travel/Holiday, Smithsonian,* and *Islands.* He won "Travel photographer of the Year" from the Society of American Travel Writers in 1994, 2007, and 2008.

For *National Geographic,* Bob has led round-the-world tours and a traveling lecture series. His book *In Tuscany* with Frances Mayes spent a month on *The New York Times'* bestseller list and his how-to book *Spirit of Place* was hailed by *American Photographer* magazine as "the best book about travel photography we've ever read." Visit Bob's website at bobkrist.com

The parents of three sons, Bob and his wife live in New Hope, Pennsylvania.

**THANK YOU** for reading PhotoSecrets. As a fellow fan of travel and photography, I hope this guide will help you quickly find the most visually stunning places, and come home with equally stunning photographs.

PhotoSecrets shows you all the best sights. Flick through, see the classic shots, and use them as a departure point for your own creations. Get ideas for composition and interesting viewpoints. See what piques your interest. Know what to shoot, why it's interesting, where to stand, when to go, and how to get great photos. Now you can spend less time researching and more time photographing.

The idea for PhotoSecrets came during a trip to Thailand, when I tried to find the exotic beach used in the James Bond movie *The Man with the Golden Gun*. None of the guidebooks I had showed a picture, so I thought a guidebook of postcard photos would be useful for us photographers. Twenty-plus years later, you have this guide. Thanks!

Now, start exploring — and take lots of photos!

On a round-the-world trip, **Andrew Hudson** wanted to find the exotic beach used in the James Bond movie *The Man with the Golden Gun*. None of the travel guides he had showed its location so he imagined a Lonely Planet book for photographers. In 1995, he quit his job as a telecom engineer and started PhotoSecrets.

His first book won the Benjamin Franklin Award for Best First Book and his second won the Grand Prize in the National Self-Published Book Awards. He has published 15 nationally-distributed color photography books.

Andrew has photographed assignments for *Macy's*, *Men's Health* and *Seventeen*, and been a location scout for *Nikon*. His photos and articles have appeared in *National Geographic Traveler*, *Alaska Airlines*, *Shutterbug*, *Where Magazine*, and *Woman's World*. He lives with his wife, two kids, and two chocolate Labs, in San Diego, California.

# ⓘ Introduction

| 👁 At a Glance | |
|---|---|
| ⓘ **Name:** | Município de Lisboa (Municipality of Lisbon) |
| 🌐 **GPS:** | 38.70694, -9.13528 |
| **Nickname:** | A Cidade das Sete Colinas (The City of Seven Hills) |
| **Country:** | Portugal |
| **Population:** | 2,827,514 (metro) |
| **Timezone:** | WET (UTC) |

**Lisbon** (in Portuguese, Lisboa) offers photographers a wealth of opportunities: an iconic tower, romantic trams and fairytale castles.

One of the word's oldest cities, Lisbon predates London, Paris and Rome by centuries. Celts and Phoenicians used the natural harbor of the Tagus estuary and fortified a hill, now the São Jorge Castle and the center of Lisbon. Julius Caesar made it a municipium called Felicitas Julia, adding to the name Olissipo. Ruled by a series of Germanic tribes from the 5th century, it was captured by the Moors in the 8th century. In 1147, the Crusaders under Afonso Henriques reconquered the city and since then it has been a major political, economic and cultural centre of Portugal.

The city of Lisbon is rich in architecture with Romanesque, Gothic, Manueline, Baroque, Modern and Postmodern constructions found all over.

The capital and the largest city of Portugal, Lisbon is mainland Europe's westernmost capital city and the only one along the Atlantic coast. The surrounding Lisbon Metropolitan Area has a population of around 2.8 million people.

Alfama (the original Moorish city) is the oldest district of Lisbon, spreading on the slope between the mediaeval São Jorge Castle and the Tejo river. Lisbon Cathedral (12th–14th centuries), the Monastery of São Vicente de Fora (late 16th–18th century) and Church of Santa Engrácia (17th century) are other highlights of this picturesque labyrinth of narrow streets and small squares. .

West of Alfama is Pombaline Lower Town (Baixa), an elegant

district, primarily constructed after the 1755 Lisbon earthquake with a grid of streets around Commerce Square (Praça do Comércio) and Rossio Square.

Belém is the southwesternmost civil parish, and includes the UNESCO World Heritage Site of Belém Tower and Jerónimos Monastery. The nearest part of the city of Lisbon to the Atlantic Ocean, Belém is where Vasco da Gama sailed to India during the Age of Discovery.

Around the city is the Lisbon Metropolitan Area (Área Metropolitana de Lisboa), split into Lisbon District (Grande Lisboa) north of the Tagus River, and Setubal District (Península de Setúbal) south of the river. Lisbon Distrcit (also known as Greater Lisbon) is the most populous Portuguese subregion, includes the cities of Lisbon, Sintra and Mafra, and the Sintra-Cascais Natural Park. This park include UNESCO World Heritage Site "Cultural Landscape of Sintra" with photographic destinations of Pena Palace and Quinta da Regaleira.

# Timeline

| | |
|---|---|
| Neolithic | Pre-Celtic tribes |
| 2000 BC | Indo-European Celts |
| 1200 BC | Phoenicians |
| 200 BC | Romans |
| 400 | Suebi (Visigoth) |
| 711 | Muslim Berbers and Arabs |
| 1108 | Norwegian crusaders |
| 1111 | Moorish Almoravids |
| 1147 | Christian rule (Afonso I of Portugal) |
| 1255 | Capital of Portugal |
| 1494 | Spain and Portugal divide the New World between them at the Tordesillas Meridian |
| 1498 | Vasco da Gama's expedition to India, a voyage that would bring immense riches to Lisbon and cause many of Lisbon's landmarks to be built. |
| 1500 | Brazil "discovered" by Portugal |
| 1580 | Spanish rule |
| 1640 | Portuguese independence |
| 1668 | Treaty of Lisbon |
| 1706-50 | Reign of John V with gold and diamonds from Brazil making Lisbon rich |
| 1755 | Earthquake destroyed 85 percent of the city's structures |
| 1807 | France invades Portugal, royal family flee to Brazil |
| 1815 | Brazil elevated in rank, equal to Portugal |
| 1821 | King João VI and the royal family return to Lisbon |
| 1822 | Brazil independence |
| 1910 | End of monarchy (First Republic) |
| 1939-45 | Neutral Atlantic port, refugees flee to the U.S. |
| 1926–74 | Estado Novo regime (Second Republic) |
| 1974 | Carnation Revolution, current Portuguese Third Republic |

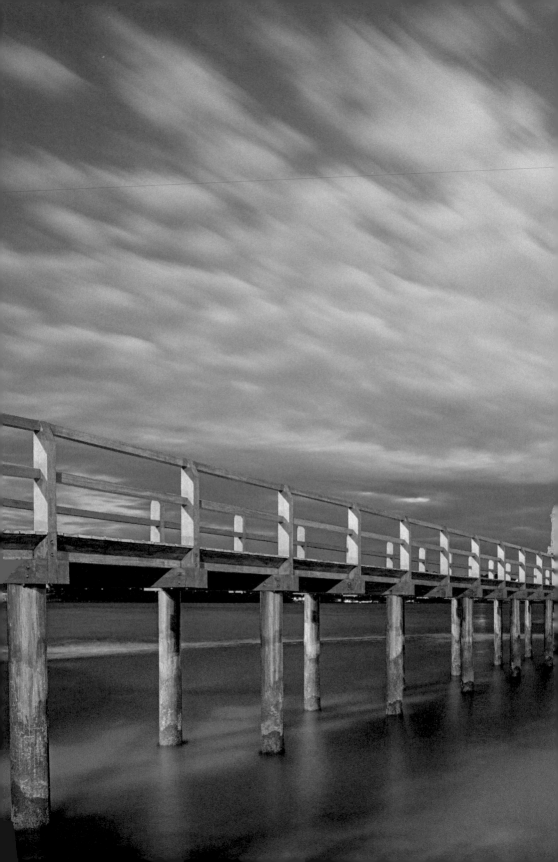

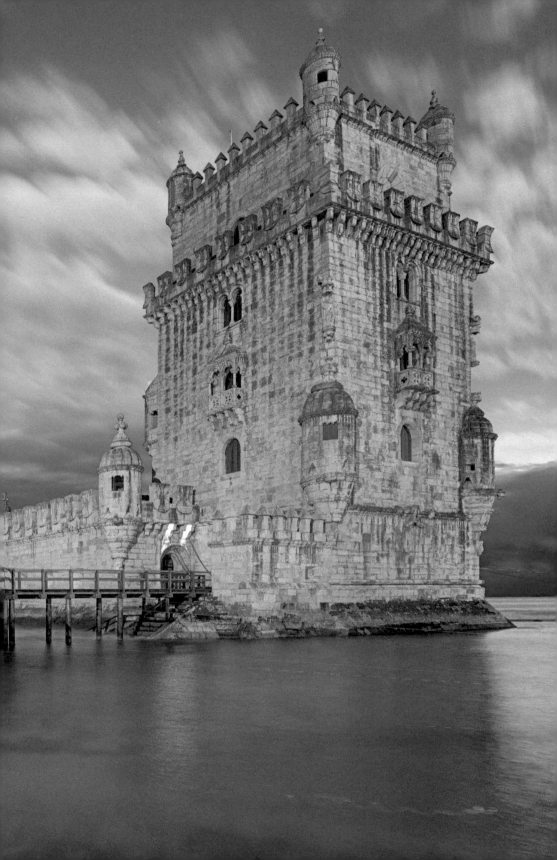

**Belém Tower** (Torre de Belém), or the Tower of St Vincent is the icon of Lisbon — a romantic reminder of the city's sea-faring past — and the perfect place to start your journey of photographic exploration. Built in the 16th century to repel attackers, the romantic island fort now beckons photographers, with views from sunrise to sunset, from around a cove.

The 16th-century tower is considered one of the principal works of the Portuguese Late Gothic Manueline style. Used as a battlement, a prison, a customs house and a lighthouse, it is now a UNESCO World Heritage Site, along with the nearby Jerónimos Monastery.

In the late 15th century, King John II ordered "a strong fort" to augment defences along the river mouth. His successor, King Manuel I, commissioned "the Belém stronghold" tower to be built on a basaltic rock outcrop a short distance from the riverbank. Designed by military architect Francisco de Arruda, construction began in 1516, using beige-white limestone local to the Lisbon area called lioz. Operational in 1519, the fortress was named the Castle of St Vincent (Castelo de São Vicente de Belém), in honor of the patron saint of Lisbon.

The building is divided into two parts: a 30-meter (98.4 ft), four-story tower, and a hexagonal bastion.

The tower was integrated with the local shoreline in 1953-6, and restored in 1997-8.

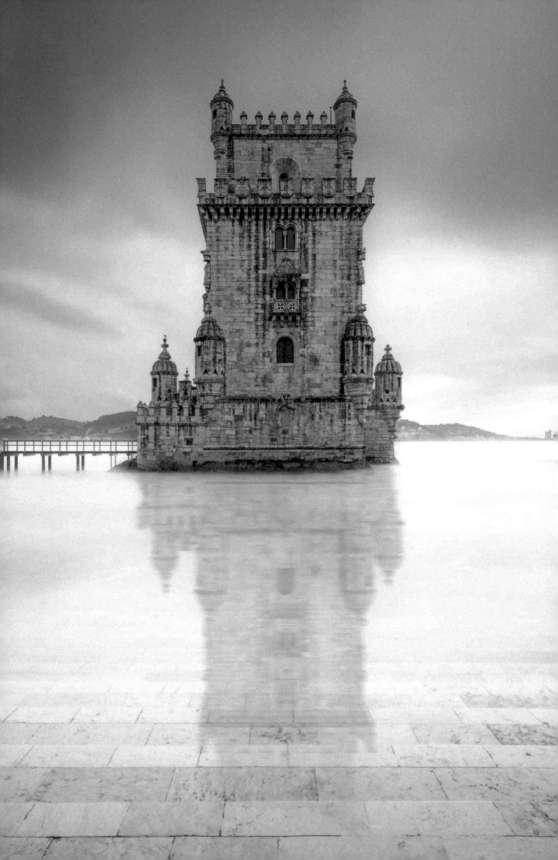

## Photographing Belém Tower

**Belém Tower** and the area around it is designed for photographers. While appearing to be in the middle of the Tagus River, the fort is actually only a few feet from the shoreline, with a 180-degree arcing pathway to give plenty of viewpoints. This could be a movie set.

In the morning, photograph from the east side to capture the golden light of sunrise. A wooden walkway at the northeast point provides an excellent leading line into the tower. You can shoot from the left side, right side, above and below.

From the north you can take a vertical shot of the tower, with the bastion hidden behind. Note that the water here is an estuary, with the Tagus River emptying into the Atlantic Ocean. So track the tide charts to get more water at high tide and less at low tide.

If you're like me, you'll be arriving at late afternoon. Fortunately, there are a wealth of sunset and dusk shots, from a wall and pathway to the west of the tower. Set up a tripod, or support your camera on a solid surface, and photograph as the sun goes down, to get the perfect light.

The tower and bastion are ringed by twelve bartizans, romantic turrets which overhang the walls at junctures for extra defence. The best shot is from the wooden bridge, viewing the southeast bartizan. These cylindrical turrets (also called guerites) were used as watchtowers and have domes covered with ridges unusual in European architecture, topped with ornate finials.

The exterior has copious decoration, with crosses on every side and, on the north corners, statues of Saint Vincent of Saragossa and the archangel Michael.

The entrance on the northeast angle includes a drawbridge and the royal coat of arms.

The interior has tiled floors, arched windows and vaulted ceilings. The southern bastion has a casemate — a battery of 17 canons in an arc, ready to fire on invaders. There is a circular staircase at the north end.

At the top of the tower, you can photograph the Renaissance loggia, an arcade with seven arches.

The roof of the bastion can be explored. The terrace is enclosed by a low wall with colonnaded pyramidal merlons.

| ✉ Addr: | | 📍 Where: | 38.691665 -9.215866 |
|---|---|---|---|
| ❓ What: | Tower | 🕐 When: | Afternoon |
| 👁 Look: | North | Ⓦ Wik: | Belém_Tower |

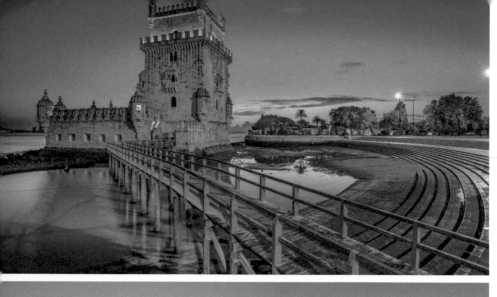

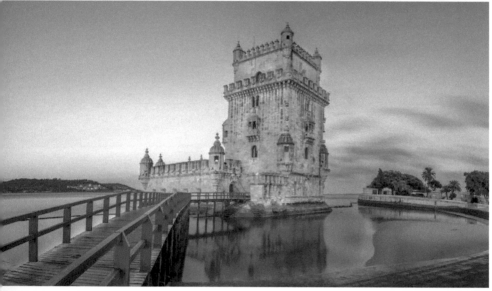

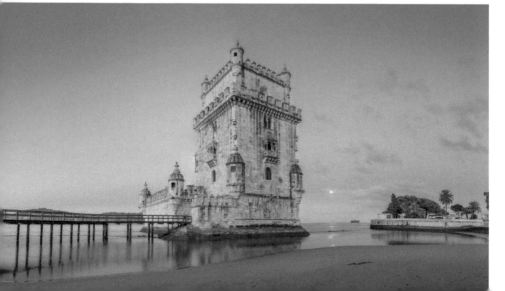

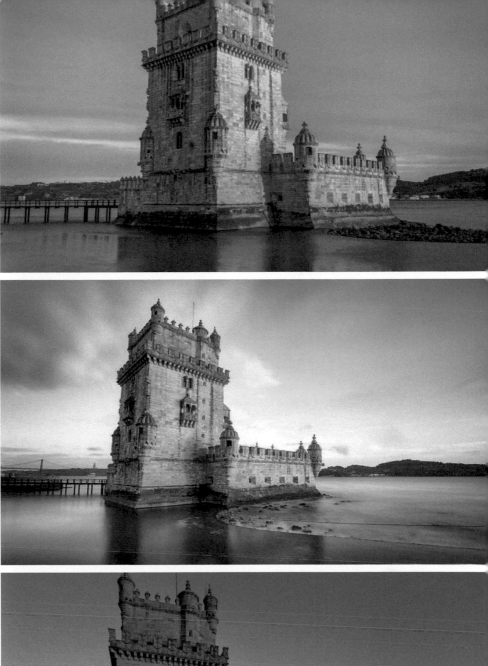
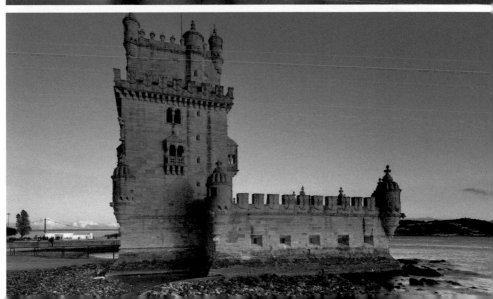

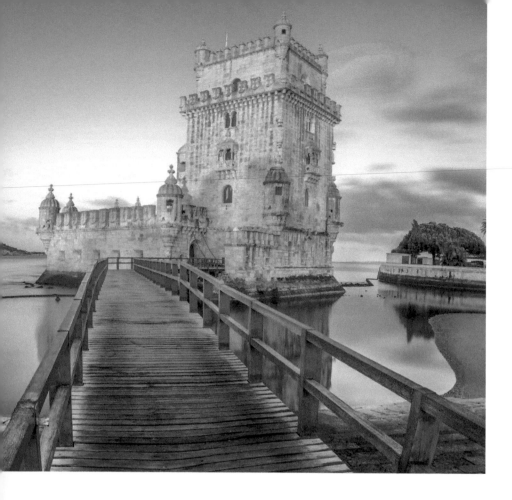

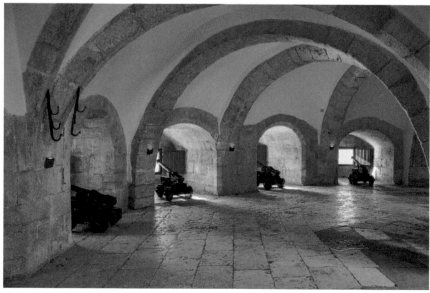

City of Lisbon > Santa Maria Maior > Belém > Belém Tower Garden

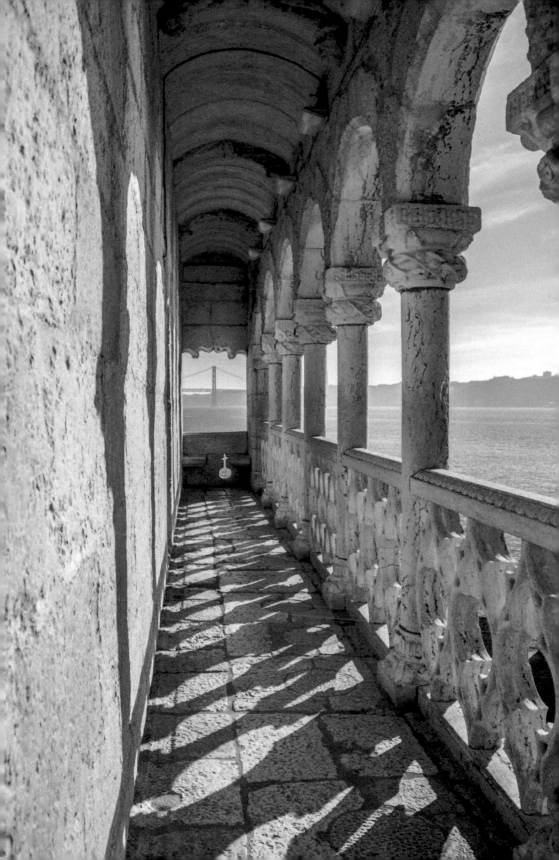

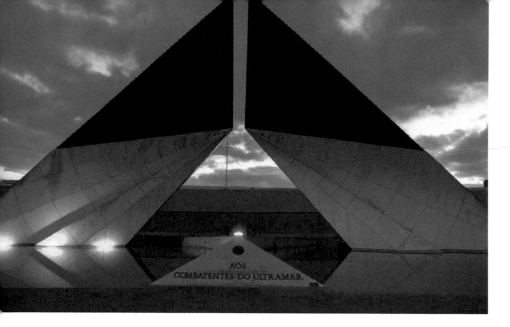

## Overseas Combatants Monument (Monumento aos
Combatentes do Ultramar) honors over 9,000 soldiers (many from
Lisbon) that died in the Overseas War of 1961 to 1974, trying to keep
Portugal's African colonies.

 Designed by Carlos Guerrero and Batista
Barros and installed in 2000, the monument
features two diagonal pillars rising from
water over an eternal flame. The monument
is 720 feet (220 m) west of Belém Tower and is
lit during dusk.

Try a shot from the north corner, with the full length of the
turquoise pool.

| ✉ **Addr:** | 1400-038 Lisbon, Portugal | ♀ **Where:** | 38.692774 -9.21781 | |
|---|---|---|---|---|
| ❓ **What:** | Monument | ◑ **When:** | Anytime | |
| 👁 **Look:** | Southwest | ↔ **Far:** | 18 m (59 feet) | |

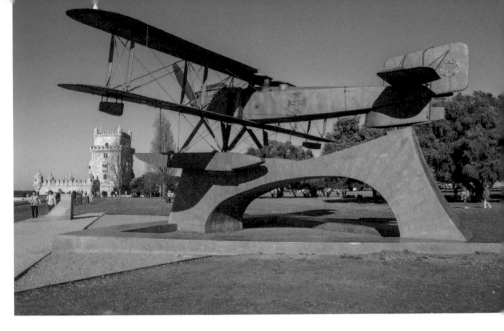

## Sacadura Cabral and Gago Coutinho Monument

commemorates the first aerial crossing of the South Atlantic, by Portuguese aviators Sacadura Cabral (1881-1924) and Gago Coutinho (1869–1959). In 1922, the pair left from this area of Lisbon and flew toward Rio de Janeiro, Brazil, to mark the centennial of Brazil's independence from Portugal.

Three different British Fairey IIID seaplanes were used, as two were lost in the waters off Brazil. The monument portrays the third one, named "Santa Cruz", which landed in Rio. The original is in the Navy Museum.

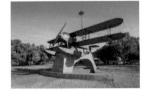

The monument is 600 feet (180 m) east of Belém Tower.

| ✉ **Addr:** | 1400-038 Lisbon, Portugal | ♀ **Where:** | 38.692259 -9.213754 |
|---|---|---|---|
| ❓ **What:** | Monument | ⏲ **When:** | Morning |
| 👁 **Look:** | West-southwest | ↔ **Far:** | 17 m (56 feet) |

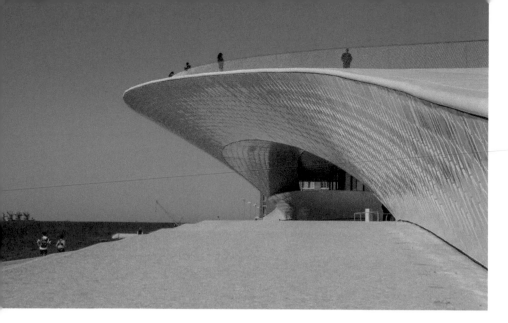

**MAAT** (Museum of Art, Architecture and Technology / Museu de Arte, Arquitetura e Tecnologia) is a museum with flowing architecture overlooking the Tagus rive. Owned by electricity company EDP (Energias de Portugal), the building was designed by British architect Amanda Levete and opened in 2016.

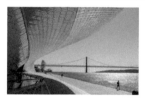

| ✉ **Addr:** | Av. Brasília, 1300-598 Lisboa | ♀ **Where:** | 38.695888 -9.193783 |
| --- | --- | --- | --- |
| ❓ **What:** | Amanda levete | ◑ **When:** | Afternoon |
| 👁 **Look:** | East | Ⓦ **Wik:** | Museum_of_Art,_Architecture_and_Technology |

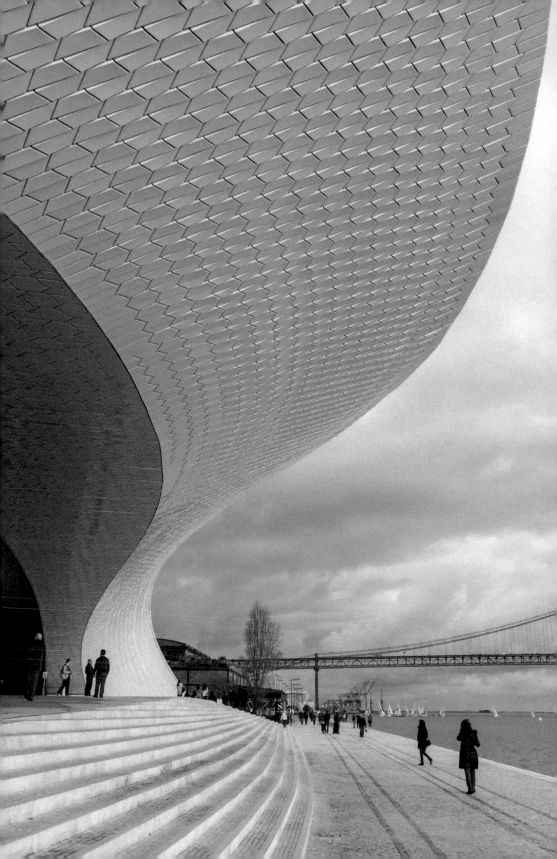

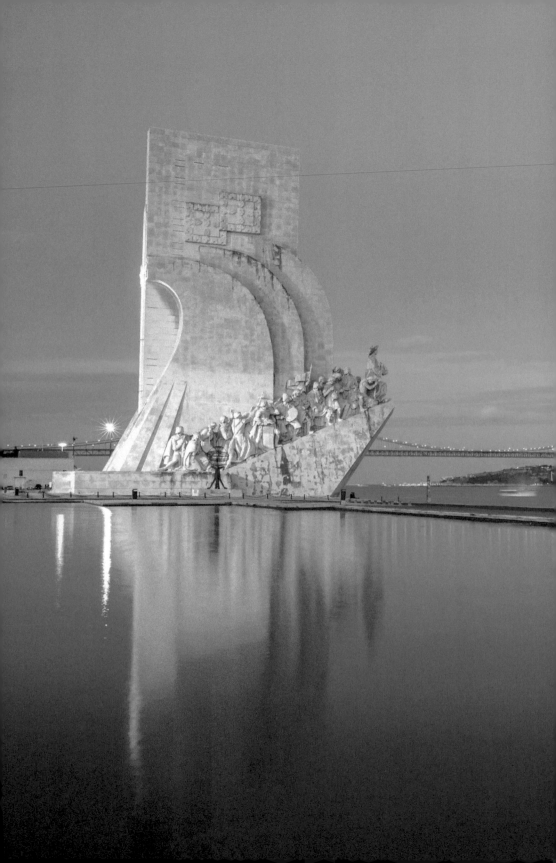

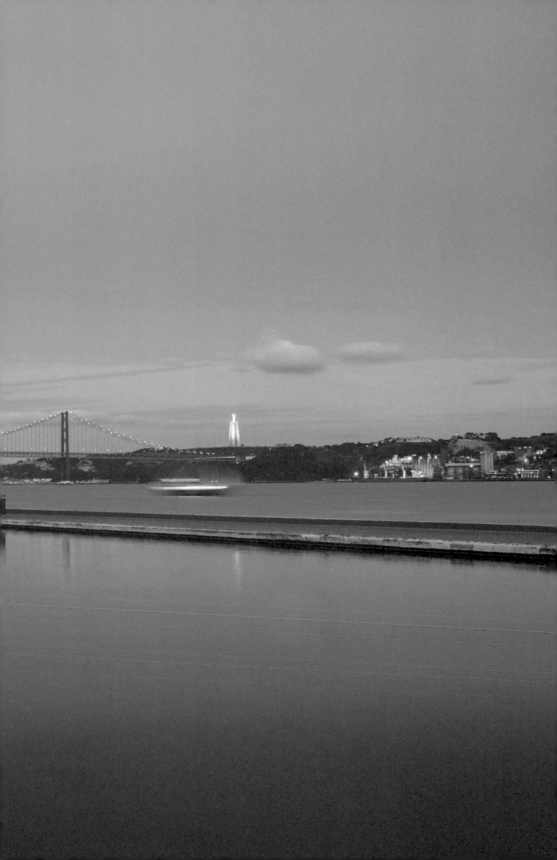

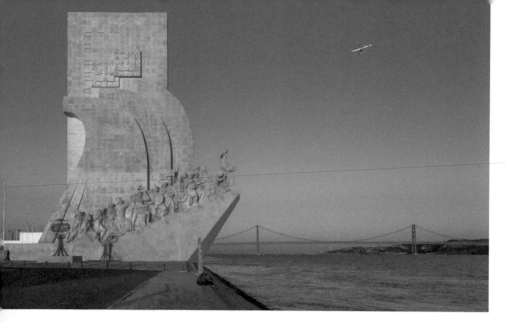

**Monument of the Discoveries** (Padrão dos Descobrimentos) celebrates the Portuguese Age of Discovery (or Age of Exploration) during the 15th and 16th centuries.

Located along the river where ships departed to explore and trade with India and the Orient, the monument is a 50 m (164 ft) tall concrete block with an observation deck on the top.

The monument was conceived in 1939 by Portuguese architect José Ângelo Cottinelli Telmo, and sculptor Leopoldo de Almeida, as a temporary beacon during the Portuguese World Exhibition opening in June 1940. The current permanent (and larger) version was built 1958-60, with a cultural center and rooftop deck added in 1985.

The design takes the form of the prow of a caravel (a ship used in the early Portuguese exploration). On either side are ramps that join at the river's edge, with the figure of Henry the Navigator holding a model of a carrack. On either side of him are 16 figures (33 in total) representing figures from the Portuguese Age of Discovery.

The figures include: Vasco da Gama (discoverer of the sea route to India), Pedro Álvares Cabral (discoverer of Brazil) and Ferdinand Magellan (first to circumnavigate the globe).

To the north is a monumental square, with large armillary spheres. Laid in the ground is a 50-metre-diameter (160 ft) Rosa-dos-Ventos (compass rose). Designed by the architect Cristino da Silva, it includes a Mappa mundi that is 14 meters wide, showing the routes of Portuguese carracks and caravels during the Age of Discovery.

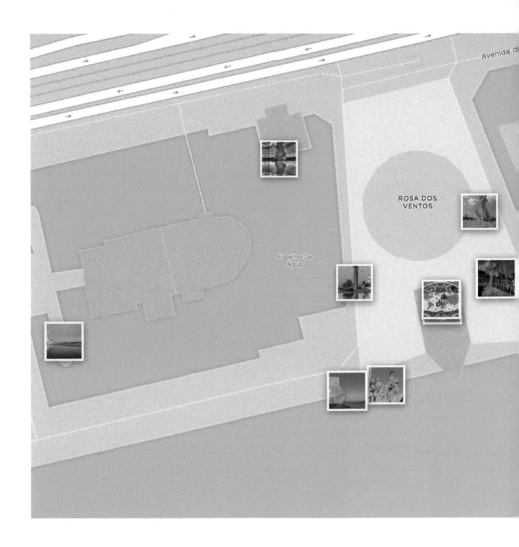

| ✉ **Addr:** | Av Brasília,<br>1400-038 Lisbon | ♀ **Where:** | 38.693325<br>-9.206366 |
| ❓ **What:** | Monument | ⏵ **When:** | Afternoon |
| 👁 **Look:** | East | W **Wik:** | Padrão_dos_Descobrimentos |

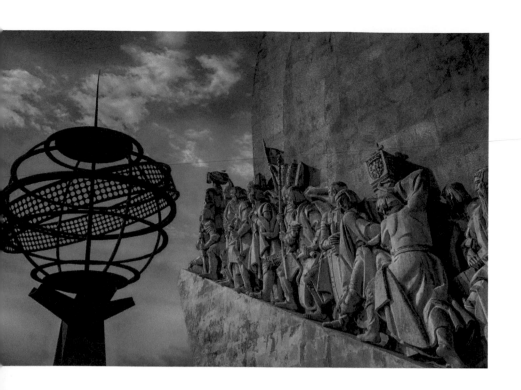

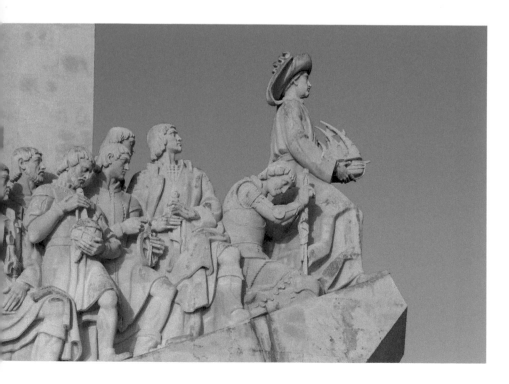

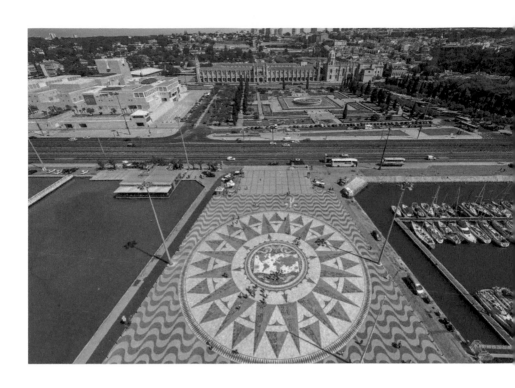

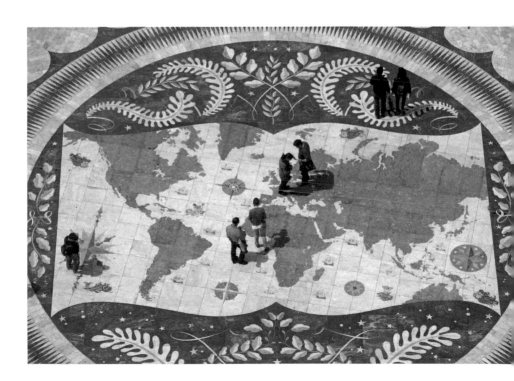

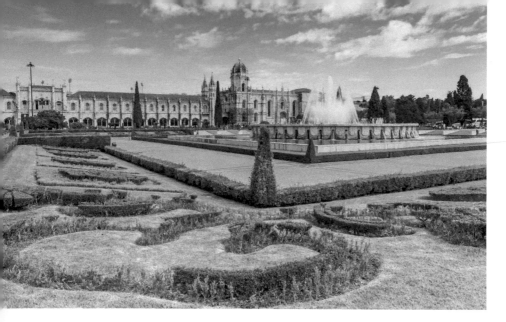

**Jerónimos Monastery** (Mosteiro dos Jerónimos) or
Hieronymites Monastery is one of the most prominent examples of
the Portuguese Late Gothic Manueline style of architecture in Lisbon.
Built from 1501 to 1601 and funded originally by a tax on commerce
from Africa and the Orient, the richly ornate design includes
maritime elements and objects discovered during naval expeditions.

These photos are taken from Empire
Square (Praça do Império), a park with a
central fountain. You can get a great aerial
shot from the top of Monument of the
Discoveries.

| ✉ **Addr:** | | ♀ **Where:** | 38.695513 -9.206334 | |
|---|---|---|---|---|
| ❷ **What:** | Former monastery | ◐ **When:** | Afternoon | |
| 👁 **Look:** | North | W **Wik:** | Jerónimos_Monastery | |

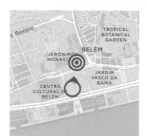

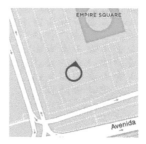

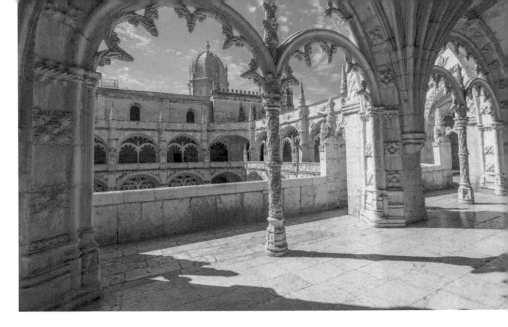

The **cloister** of Jerónimos Monastery features beautiful reticulated vaulting and Manueline ornamentation around a large courtyard. The arcades include traceried arches that give the construction a filigree aspect.

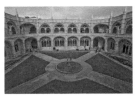

| ✉ **Addr:** | | ♀ **Where:** | 38.6983509 -9.2058474 | |
|---|---|---|---|---|
| ❷ **What:** | Cloister | ◑ **When:** | Afternoon | |
| 👁 **Look:** | South | ↔ **Far:** | 80 m (280 feet) | |

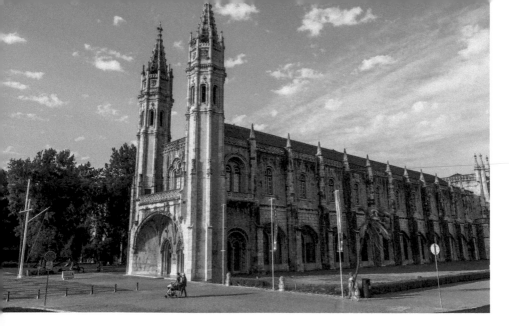

**Navy Museum** (Museu de Marinha) is a maritime museum occupying part of the neo-Manueline Western wing of the Jerónimos Monastery, as well as a modern annex north of the monastery.

In 1863, King Luís I (1838-1889), an accomplished navigator, began collecting items related to the preservation of maritime history of Portugal. The collection was enlarged in the following decades, culminating in the inauguration of the Maritime Museum in 1963.

The exhibits include many scale models of ships used in Portugal since the 15th century, a collection of navigations instruments and maps, royal barges, as well as the Fairey III "Santa Cruz" that crossed the Atlantic in 1923.

| ✉ **Addr:** | Praça do Império, 1400-038 Lisboa | ♀ **Where:** | 38.696917 -9.208205 |
| --- | --- | --- | --- |
| ❓ **What:** | Museum | ⏻ **When:** | Afternoon |
| 👁 **Look:** | North-northeast | W **Wik:** | Navy_Museum_(Portugal) |

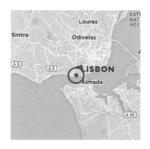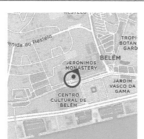

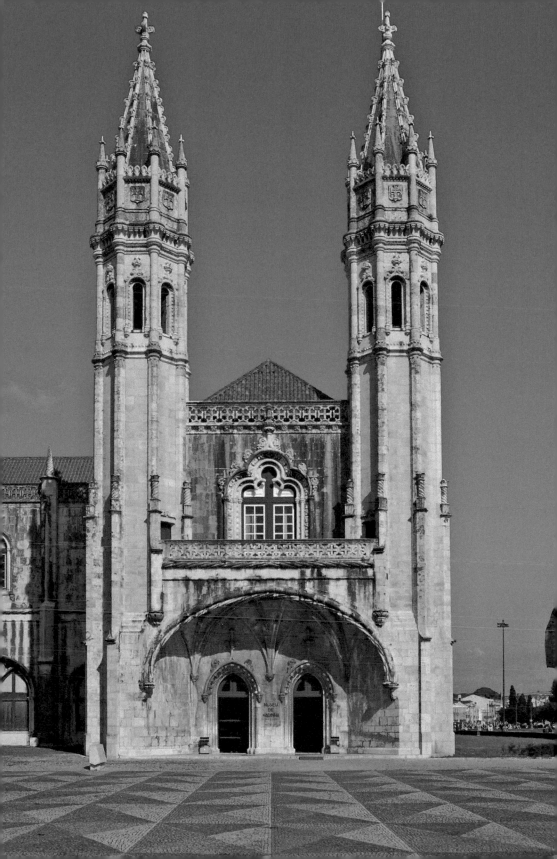

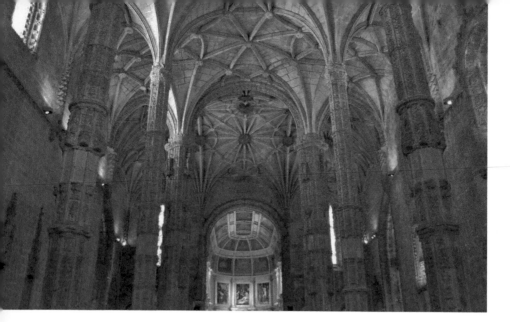

**Santa Maria Church** (Igreja da Maria de Belém) is the church of the Jerónimos Monastery. The nave displays high vaulted ceiling and a golden main chapel. Outside, the ornate Manueline south portal is by João de Castilho.

| ✉ **Addr:** | Praça do Império, 1400-038 Lisbon | ⚲ **Where:** | 38.697697 -9.2057179 |
| **❓ What:** | Church | **◑ When:** | Anytime |
| **👁 Look:** | East-northeast | W **Wik:** | Jer%C3%B3nimos_Monastery#Church_of_Santa_Maria |

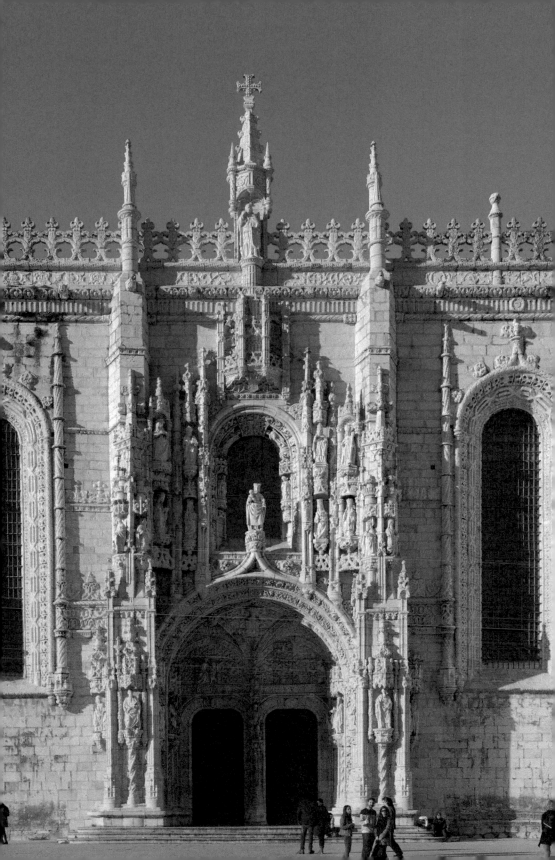

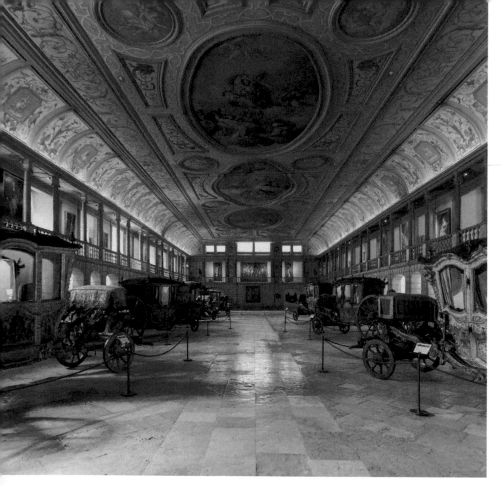

## National Coach Museum (Museu Nacional dos Coches) has
one of the finest collections of historical carriages in the world and is
one of the most-visited museums of the city.

| ✉ **Addr:** | Av da Índia 136, 1300-004 Lisbon | ♥ **Where:** | 38.696593 -9.197523 |
| --- | --- | --- | --- |
| ❷ **What:** | Museum | ◑ **When:** | Anytime |
| 👁 **Look:** | West | W **Wik:** | National_Coach_Museum |

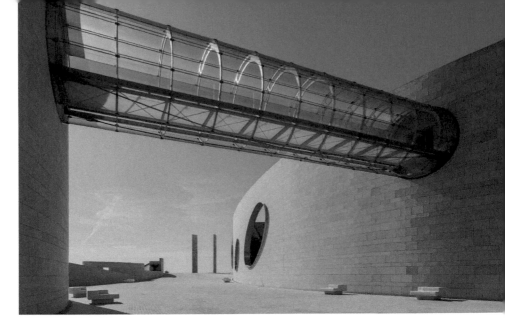

## Champalimaud Foundation (Fundação Champalimaud) is a
private biomedical research foundation created in 2004 by
entrepreneur António de Sommer Champalimaud. Opened in 2014,
the complex was designed by Indian architect Charles Correa and
includes a skybridge in a glass tube.

| ✉ **Addr:** | Av. Brasília,<br>1400-038 Lisbon | 📍 **Where:** | 38.693342<br>-9.221022 |
|---|---|---|---|
| ❓ **What:** | Building | 🕐 **When:** | Morning |
| 👁 **Look:** | West-southwest | W **Wik:** | Champalimaud_Foundation |

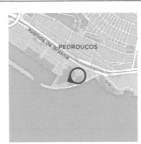

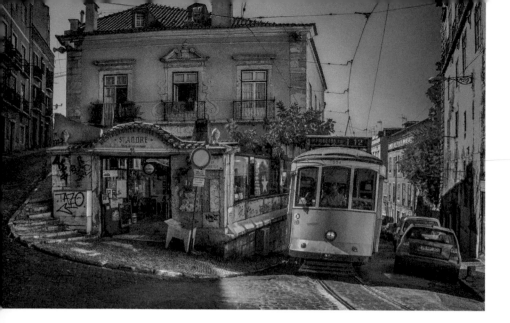

**Saint Andrew Restaurant** (Restaurante Saint André) has a scenic location next to the tram line.

| ✉ **Addr:** | Costa do Castelo 91, 1100-005 Lisbon | ♀ **Where:** | 38.714485 -9.131204 |
|---|---|---|---|
| ❓ **What:** | Restaurant | ◑ **When:** | Morning |
| 👁 **Look:** | Northwest | ↔ **Far:** | 14 m (46 feet) |

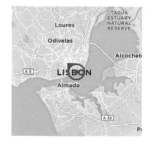
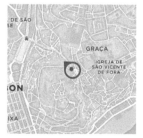

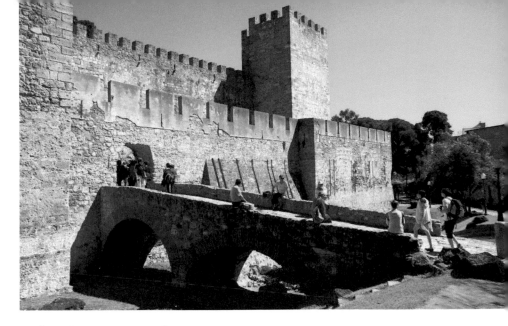

## Saint George Castle

**Saint George Castle** (São Jorge Castle) is a medieval Moorish castle occupying a commanding hilltop overlooking the historic centre of Lisbon. The castle is part of a strongly fortified citadel and is one of the main tourist sites of Lisbon.

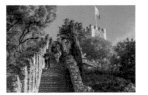

The hill was first used by indigenous Celtic tribes, then by Phoenicians, Greeks, Carthaginians and Romans as a defensible outpost. During the 10th century, the fortifications were rebuilt by Muslim Berber forces. By 1375, the castle had 77 towers and a perimeter of 5,400 metres (17,700 ft).

| ✉ **Addr:** | R. de Santa Cruz do Castelo, 1100-129 Lisbon | ♀ **Where:** | 38.713419 -9.133470 |
|---|---|---|---|
| ❷ **What:** | Castle | ☉ **When:** | Afternoon |
| 👁 **Look:** | Northeast | Ⓦ **Wik:** | São_Jorge_Castle |

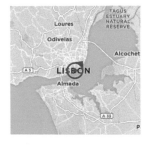
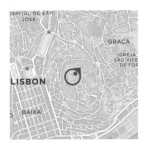

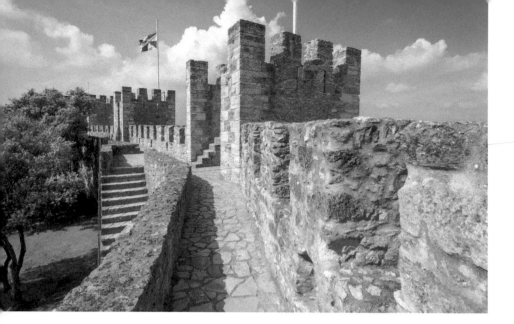

The **walls of Saint George Castle** can be walked for the entire perimeter. A series of stairways allow visitors to reach the walkway atop the wall and the towers, from which magnificent views of Lisbon can be enjoyed. The Tower of Ulysses (where the Torre do Tombo archive used to be) had in 1998 a camera obscura installed that allows spectators a 360-degree view of the city and Tagus River.

| ✉ **Addr:** | R. de Santa Cruz do Castelo, 1100-129 Lisbon | ♀ **Where:** | 38.713706 -9.133669 |
|---|---|---|---|
| ❓ **What:** | Wall | ☾ **When:** | Afternoon |
| 👁 **Look:** | East-southeast | ↔ **Far:** | 16 m (52 feet) |

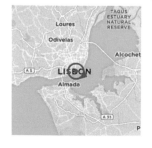
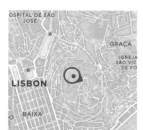
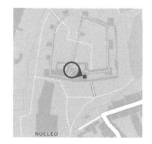

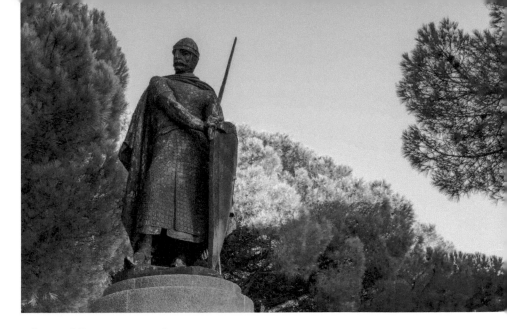

**King Alfonso Henriques** is a statue in the courtyard of São Jorge Castle of the first King of Portugal. He achieved the independence of the southern part of the Kingdom of Galicia, the County of Portugal, in 1139. He died in 1185 after forty-six years of wars against the Moors.

| ✉ **Addr:** | Rua de Santa Cruz do Castelo 1A, 1100-129 Lisboa | ♀ **Where:** | 38.7122598 -9.13353 |
| --- | --- | --- | --- |
| ❓ **What:** | Statue | ◐ **When:** | Afternoon |
| 👁 **Look:** | East-southeast | W **Wik:** | Afonso_I_of_Portugal |

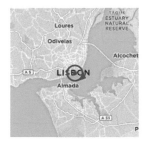
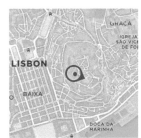

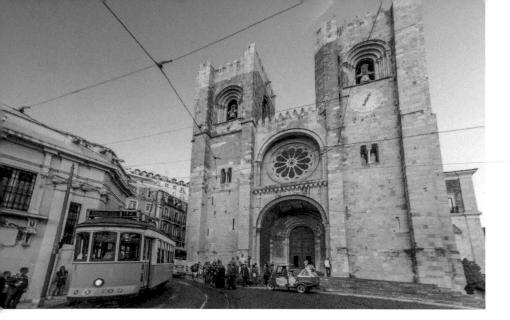

## Lisbon Cathedral (Santa Maria Maior de Lisboa, or Sé de Lisboa), often called simply the Sé, is a Roman Catholic church dedicated to St. Mary Major.

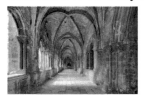

The first building was completed between 1147 and the first decades of the 13th century in Late Romanesque style. At that time, the relics of St Vincent of Saragossa, patron saint of Lisbon, were brought to the cathedral from Southern Portugal.

| ✉ **Addr:** | Largo da Sé,<br>1100-585 Lisboa | ♀ **Where:** | 38.70976<br>-9.133628 |
| --- | --- | --- | --- |
| ❓ **What:** | Cathedral | ◑ **When:** | Afternoon |
| 👁 **Look:** | East | W **Wik:** | Lisbon_Cathedral |

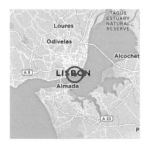
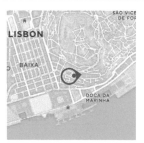
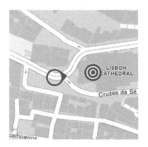

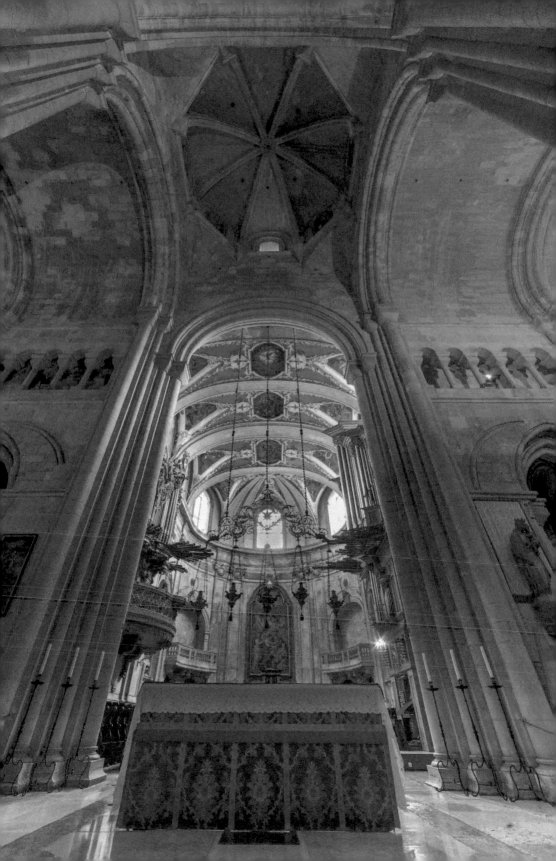

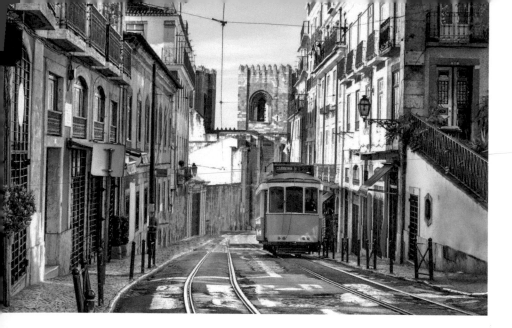

Historic **Tram 28** winds through the streets of Alfama above Lisbon Cathedral.

| | | | |
|---|---|---|---|
| ✉ **Addr:** | Largo São Martinho 18-17, 1100-001 Lisbon | ♀ **Where:** | 38.7104609 -9.1313594 |
| ◑ **When:** | Morning | ◉ **Look:** | West-southwest |
| ↔ **Far:** | 170 m (560 feet) | | |

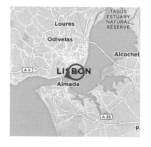  

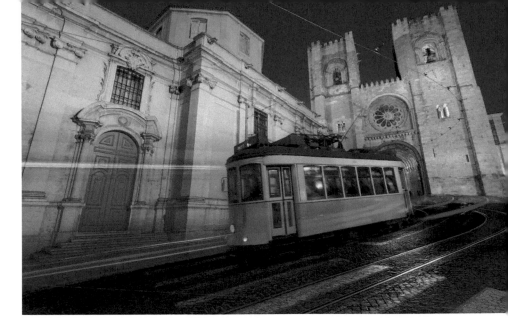

**Tram 28** heads west from Lisbon Cathedral past Santo António Church.

| ✉ **Addr:** | Largo Santo António da Sé, 1100-401 Lisbon | ♥ **Where:** | 38.709829 -9.133878 |
|---|---|---|---|
| ◑ **When:** | Anytime | ◉ **Look:** | East |
| ↔ **Far:** | 50 m (170 feet) | | |

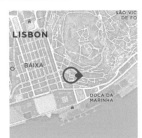
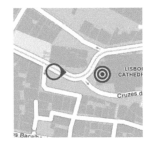

## House of the Spikes

(Casa dos Bicos) is a historical house built in the early 16th century with a curious façade of spikes, influenced by Italian Renaissance palaces and Portuguese Manueline styles. The spikes (diamond-shape protrusions) are attached to the principal façade, to the south.

| ✉ **Addr:** | Rua dos Bacalhoeiros, 1100-135 Lisbon | ♀ **Where:** | 38.709111 -9.132694 |
|---|---|---|---|
| ❓ **What:** | Museum | ⏱ **When:** | Afternoon |
| 👁 **Look:** | North | W **Wik:** | Casa_dos_Bicos |

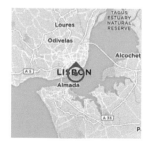

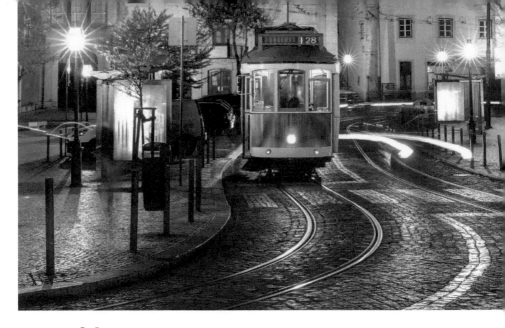

**Gates of the Sun** (Portas do Sol) is the best place to photograph the trams of Lisbon. A large "S" curve over cobblestone against a backdrop of colorful buildings provides a variety of views. Standing near Miradouro das Portas do Sol, you can photograph Portas do Sol, Largo Santa Luzia, and the statue of Saint Vincent (São Vicente).

Tram 28 is the most scenic of Lisbon's six remaining tram lines. The first tramway in Lisbon entered service in 1873, as a horsecar line. By 1902, all of the city's tramways had been converted to electric traction.

| ✉ **Addr:** | Largo Portas do Sol, 1100-411 Lisbon | ♀ **Where:** | 38.712043 -9.130265 |
| --- | --- | --- | --- |
| ❓ **What:** | Street | ⏱ **When:** | Anytime |
| 👁 **Look:** | Northwest | Ⓦ **Wik:** | Trams_in_Lisbon |

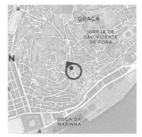
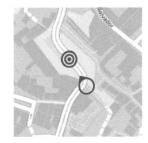

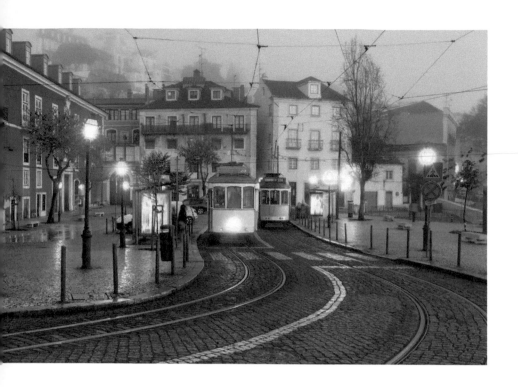

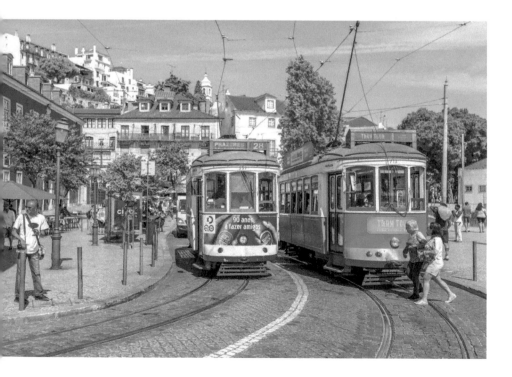

**Saint Vincent of Saragossa** is the patron saint of Lisbon. This statue stands at Portas do Sol, with the twin bell towers of his namesake Monastery of São Vicente de Fora in the background.

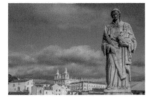

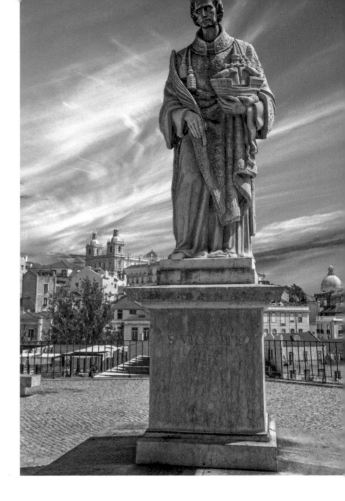

| ✉ **Addr:** | Beco de Santa Helena 25, 1100-411 Lisbon | ♀ **Where:** | 38.7121633 -9.130313 | |
|---|---|---|---|---|
| ❓ **What:** | Statue | 🕐 **When:** | Afternoon | |
| 👁 **Look:** | Northeast | Ⓦ **Wik:** | Vincent_of_Saragossa | |

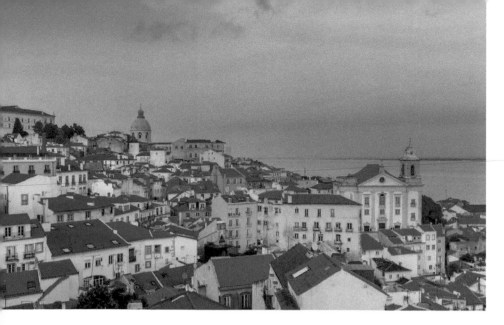

**Gates of the Sun Viewpoint** (Miradouro das Portas do Sol) is one of several terraces (*miradouros*) in the slopes of Alfama from which to see the city. This view includes the two towers of the Church of St. Vincent (São Vicente de Fora) on the left, the dome of the Church of Santa Engrácia in the center, and the tower of Saint Stephen Church (Igreja de Santo Estêvão) on the right.

Nearby is Miradouro de Santa Luzia with similar views, and a pergola (GPS 38.711818, -9.130091).

| ✉ **Addr:** | Largo Portas do Sol, 1100-411 Lisbon | 📍 **Where:** | 38.7121633 -9.1303131 |
|---|---|---|---|
| ❓ **What:** | Viewpoint | 🕐 **When:** | Afternoon |
| 👁 **Look:** | Northeast | ↔ **Far:** | 360 m (1180 feet) |

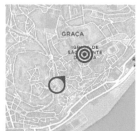

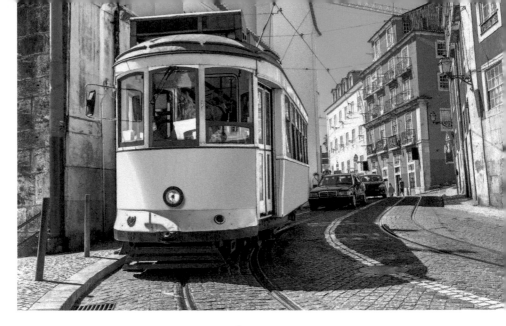

**Tram 28 at Largo Santa Luzia** turns a curve before entering Portas do Sol.

| ✉ **Addr:** | Largo Santa Luzia 11-9, 1100-411 Lisbon | ♀ **Where:** | 38.712043 -9.130265 |
|---|---|---|---|
| ◑ **When:** | Morning | ◉ **Look:** | Southwest |
| ↔ **Far:** | 7 m (23 feet) | | |

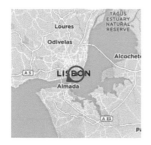

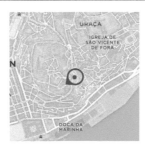

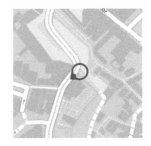

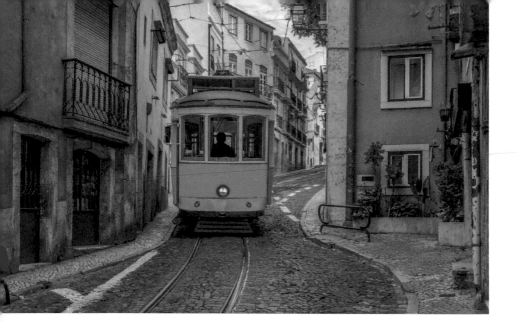

**Saint Vincent Street** (Calçada de São Vicente) provides a scenic shot of Tram 28 as it takes a dog-leg through the narrow cobblestone street.

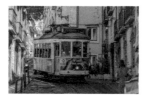

| ✉ **Addr:** | Calçada de São Vicente 81-61, Lisbon | ♀ **Where:** | 38.714099 -9.128247 | |
|---|---|---|---|---|
| ◑ **When:** | Morning | ◉ **Look:** | North-northwest | |
| ↔ **Far:** | 30 m (100 feet) | | | |

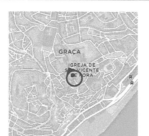
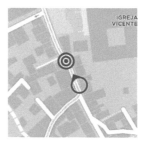

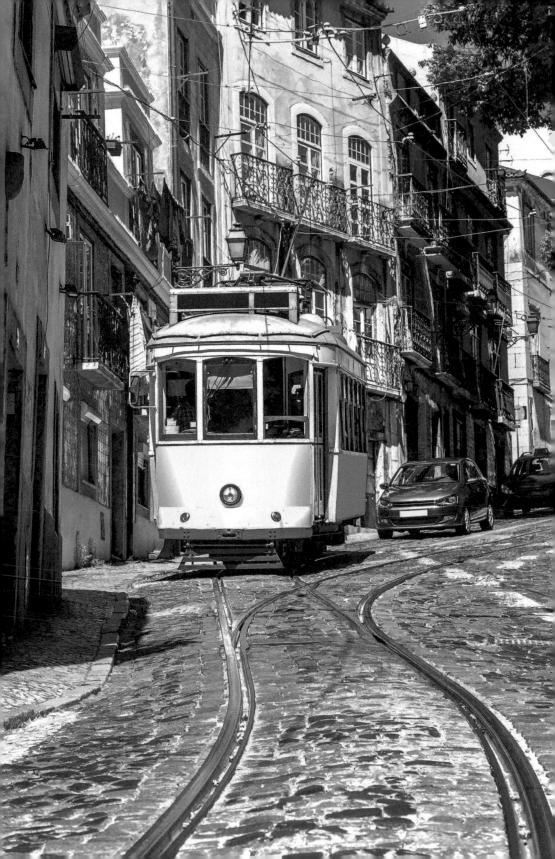

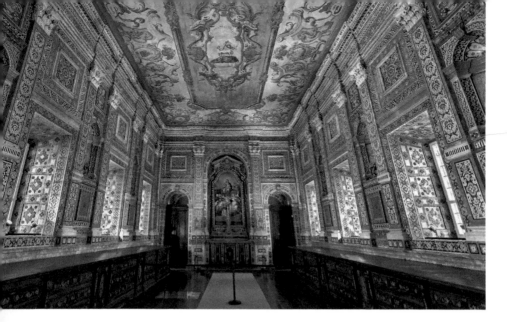

**Saint Vincent Outside the Walls** (São Vicente de Fora) is one of the most important monasteries and mannerist buildings in Portugal. The monastery also contains the royal pantheon of the Braganza monarchs of Portugal.

Founded around 1147 by the first Portuguese King, Afonso Henriques, this was one of the most important monastic foundations in mediaeval Portugal. It is dedicated to Saint Vincent of Saragossa, patron saint of Lisbon and is "outside the walls" of the Lisbon citadel.

The church of the monastery was rebuilt 1582–1629, while other monastery buildings were finished in the 18th century. Built on top of a hill, the twin bell towers can be seen from around the city.

| ✉ **Addr:** | Igreja de São Vicente de Fora, 1100-572 Lisboa | ♀ **Where:** | 38.71475 -9.128503 | |
|---|---|---|---|---|
| ❓ **What:** | Monastery | ☽ **When:** | Anytime | |
| 👁 **Look:** | East | W **Wik:** | Monastery_of_São_Vicente_de_Fora | |

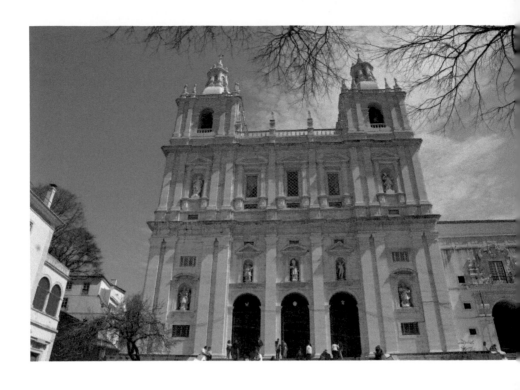

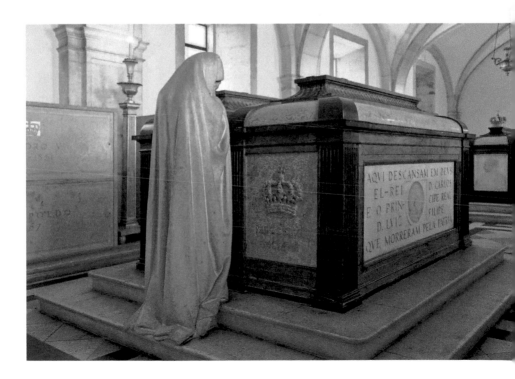

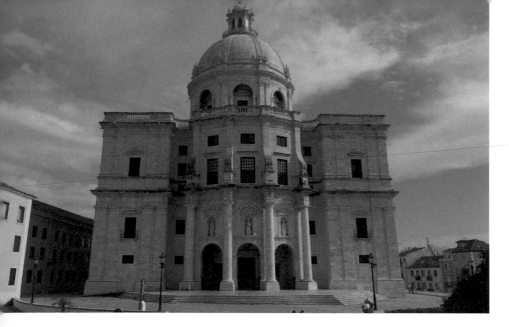

## Saint Engratia Church (Igreja de Santa Engrácia) is a 17th-century church notable for its high dome which can be seen from many points in Lisbon.

The ingenious design of four strong corner towers was by João Antunes, royal architect and one of the most important baroque architects of Portugal. Construction started in 1681 but was not completed until the 20th century, so that Obras de Santa Engrácia (literally Saint Engrácia's works) has become a Portuguese synonym for an endless construction project.

In the 20th century it was converted into the National Pantheon (Panteão Nacional), in which important Portuguese personalities are buried.

| ✉ **Addr:** | Campo de Santa Clara, 1100-471 Lisbon | ♀ **Where:** | 38.714676 -9.125304 | |
|---|---|---|---|---|
| ❷ **What:** | Church | ◐ **When:** | Afternoon | |
| 👁 **Look:** | East-northeast | Ⅶ **Wik:** | Church_of_Santa_Engrácia | |

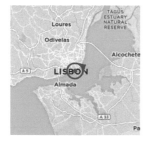 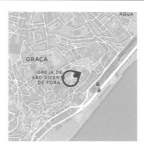 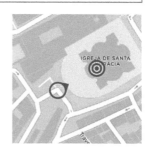

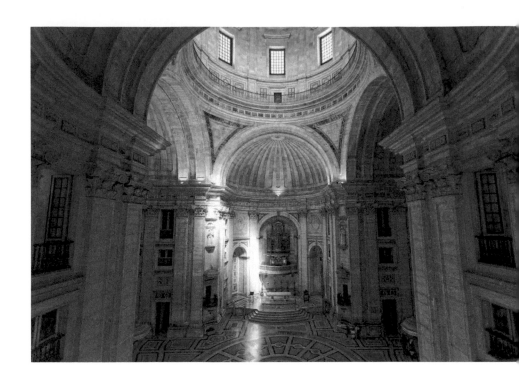

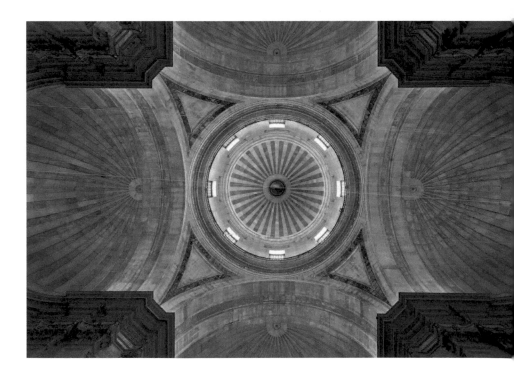

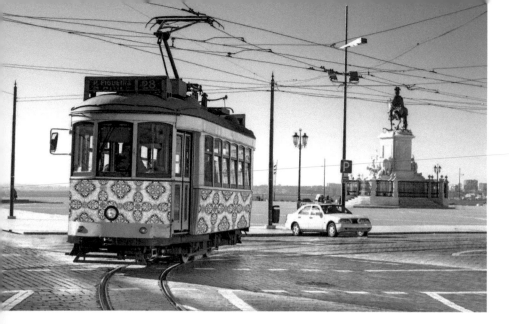

**Commerce Square** (Praça do Comércio) is a giant public area overlooking the Tagus River, with a tramline and statue of King Joseph I (Dom José I).

The square is still commonly known as Palace Yard (Terreiro do Paço) because it was the location of the Royal Ribeira Palace (Paços da Ribeira) until it was destroyed by the great 1755 Lisbon earthquake. After the earthquake, the square was completely remodeled as part of the rebuilding of the Pombaline Downtown, during the king's reign.

The equestrian statue is by Machado de Castro (1775) and shows King Joseph I (Dom José I) symbolically crushing snakes on his path.

| ✉ **Addr:** | Praça do Comércio, 1100-148 Lisbon | ⚲ **Where:** | 38.708529 -9.135949 | |
| --- | --- | --- | --- | --- |
| ☾ **When:** | Morning | ◉ **Look:** | South-southwest | 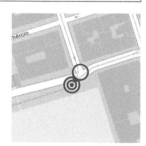 |
| W **Wik:** | Praça_do_Comércio | | | |

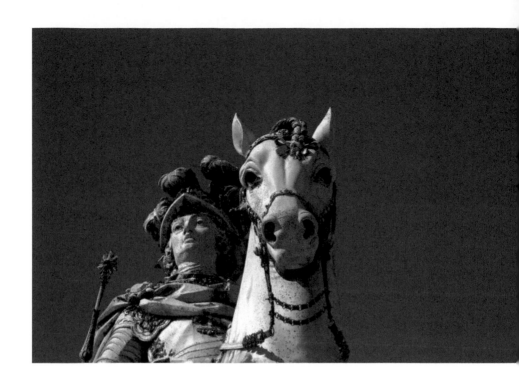

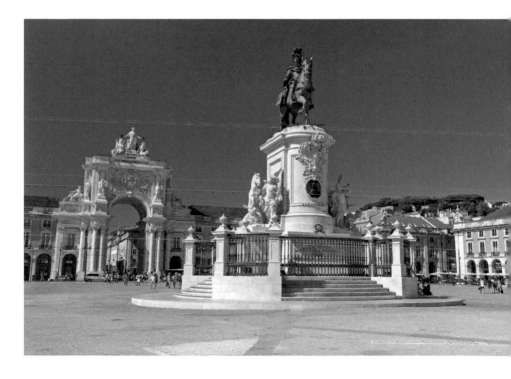

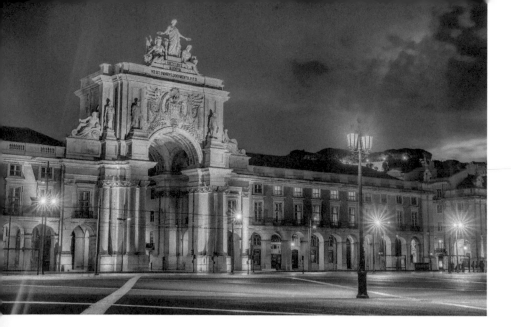

## Augusta Road Arch

**Augusta Road Arch** (Arco da Rua Augusta) is a triumphal arch at Commerce Square over the wide boulevard that connects to huge square to Rossio Square. Designed by Veríssimo da Costa, it started life as a bell tower in 1755 and was completed in 1873.

On top are giant statues of Glory, Ingenuity and Valor, by the French sculptor Calmels.

| ✉ **Addr:** | Rua Augusta 2, 1100-053 Lisbon | ♥ **Where:** | 38.708218 -9.136729 |  |
| --- | --- | --- | --- | --- |
| ❓ **What:** | Arch | ☽ **When:** | Anytime | |
| 👁 **Look:** | North-northwest | Ⅶ **Wik:** | Rua_Augusta_Arch | |

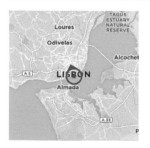
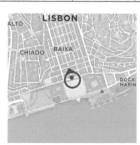

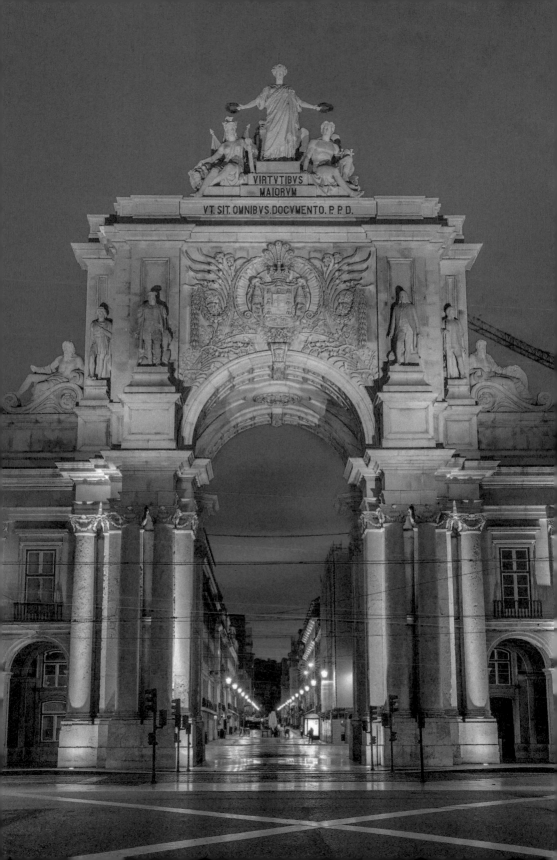

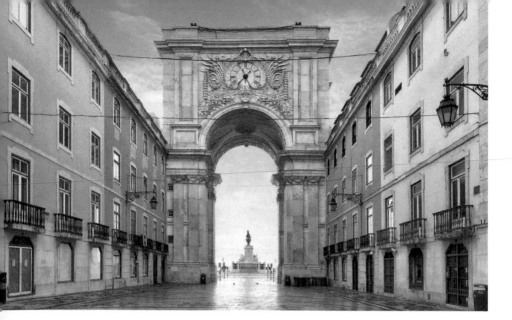

The Rua Augusta Arch flanked by buildings along Rua Augusta, with a view to Commerce Square and King José I statue.

| ✉ **Addr:** | Rua Augusta 2, 1100-053 Lisbon | 📍 **Where:** | 38.708856 -9.136956 |
| 🌓 **When:** | Afternoon | 👁 **Look:** | South-southeast |
| ↔ **Far:** | 50 m (160 feet) | | |

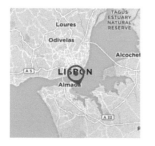

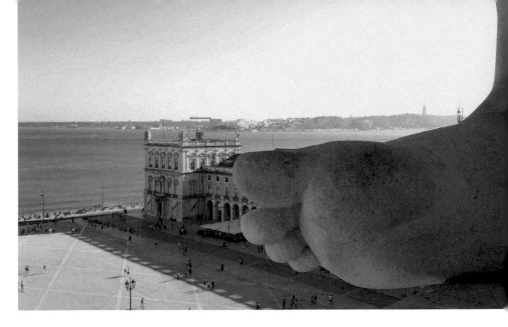

From the **top of Rua Augusta Arch** you can capture panoramic views of Lisbon from 30 m (100 feet) high.

   Above are the toes of Genius, a giant statue on top of Rua Augusta Arch overlooking Commerce Square. The view north is along Rua Augusta to Rossio Square.

| ✉ **Addr:** | Rua Augusta 2, 1100-053 Lisbon | ♀ **Where:** | 38.7084115 -9.1366842 | |
|---|---|---|---|---|
| ◑ **When:** | Afternoon | ◉ **Look:** | North | |
| ↔ **Far:** | 0 m (0 feet) | | | |

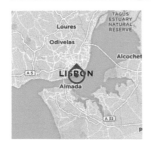
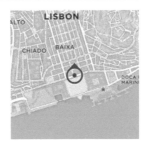

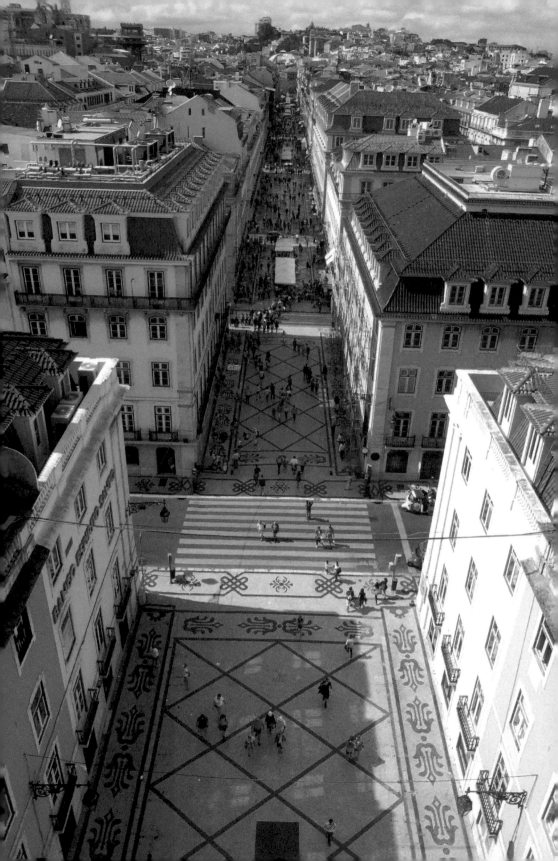

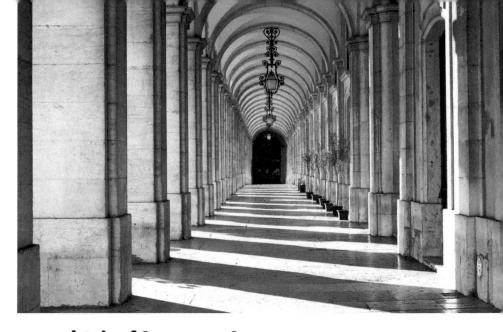

The **peristyle of Commerce Square** is a continuous porch formed by a row of columns, on three sides of the square.

| ✉ **Addr:** | Ala Poente, 1100-148 Lisbon | 📍 **Where:** | 38.707893 -9.137498 |
| --- | --- | --- | --- |
| ❓ **What:** | Peristyle | 🕐 **When:** | Afternoon |
| 👁 **Look:** | South-southeast | ↔ **Far:** | 110 m (350 feet) |

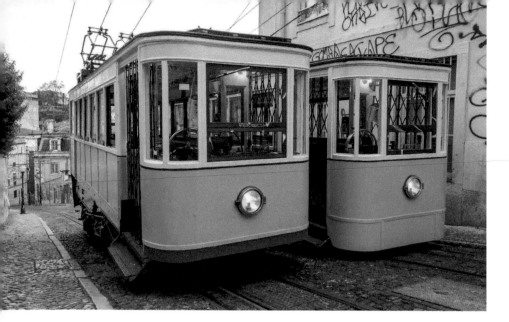

**Glória Funicular** (Ascensor da Glória), sometimes known as the Elevador da Glória, is a steep railway line that connects the Pombaline downtown (at the Restauradores Square) with the Bairro Alto (Garden/ Overlook of São Pedro de Alcântara).

Two tram cars powered by overhead lines are connected by cable, to balance the weight. You can catch them crossing reliably at the same mid-way point.

| ✉ **Addr:** | Av. da Liberdade 1, 1250-001 Lisboa | ♥ **Where:** | 38.715253 -9.143364 |
|---|---|---|---|
| ❓ **What:** | Funicular | ☽ **When:** | Afternoon |
| 👁 **Look:** | North-northeast | W **Wik:** | Ascensor_da_Glória |

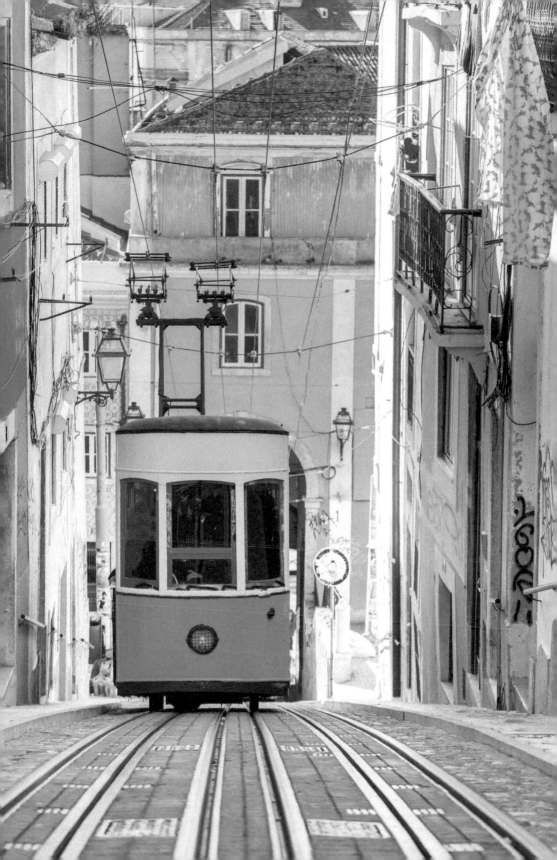

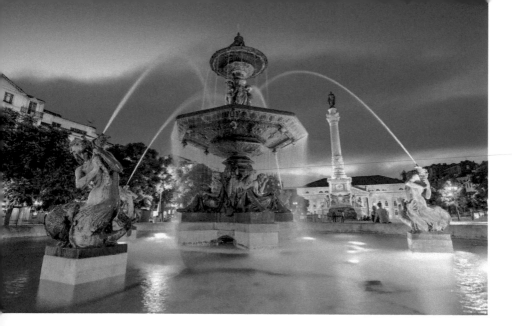

**Rossio Square** is the popular name of the King Peter IV Square (Praça de Dom Pedro IV), located in the Pombaline Downtown (Lisbon Baixa). It has been a main square since the Middle Ages, the setting of popular revolts and celebrations, bullfights and executions.

The name "rossio" is roughly equivalent to the word "commons" in English, and refers to a commonly owned terrain.

A pair of fountains flank the Column of Pedro IV, by the neoclassical Teatro Nacional D. Maria II, built in the 1840s.

Rossio Square features "Portuguese pavement" (Calçada Portuguesa), a traditional-style pavement born in Lisbon in the mid-1800s and used for many pedestrian areas in Portugal.

| ✉ **Addr:** | Praça Dom Pedro IV, 1100-200 Lisbon | ♀ **Where:** | 38.713292 -9.139029 |
|---|---|---|---|
| ❓ **What:** | Fountain | ☽ **When:** | Anytime |
| 👁 **Look:** | Northwest | W **Wik:** | Rossio_Square |

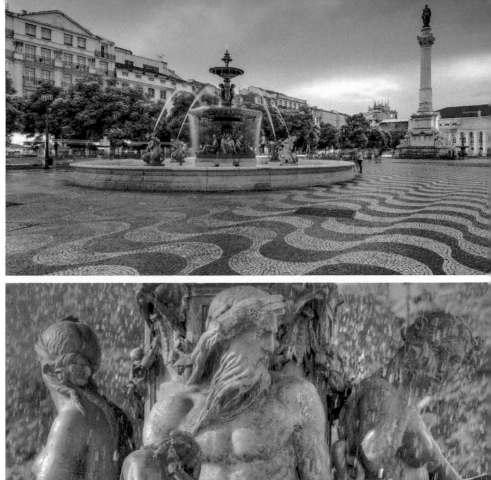

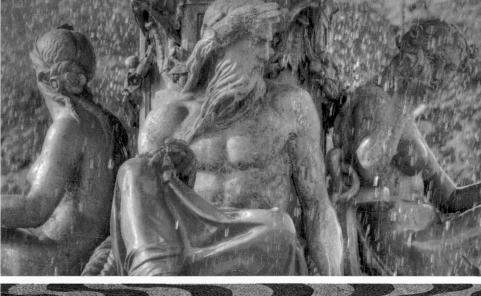

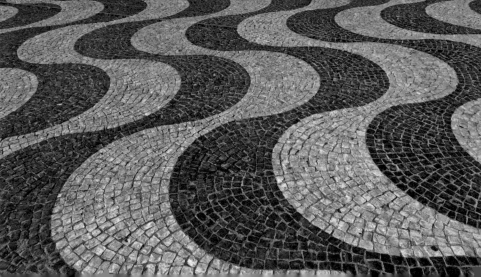

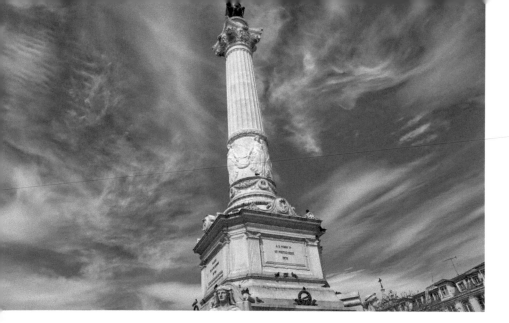

**Peter IV Monument** (Column of Pedro IV) is an 1870 column in Rossio Square honoring the king that gave Portugal a constitution.

In 1821, King John VI had a monument to the first constitution built at this location, but after absolute monarchy was reinstated, he had it torn down two years later.

The second constitution of Portugal was given to the country in 1826 by King Peter IV (Dom Pedro IV). The marble statue of 1870 depicts the king holding the Constitutional Charter in his right hand.

| ✉ **Addr:** | Praça Dom Pedro IV, 1100-200 Lisboa | ♀ **Where:** | 38.713459 -9.139230 |
| --- | --- | --- | --- |
| ❓ **What:** | Column | 🕐 **When:** | Morning |
| 👁 **Look:** | North-northwest | W **Wik:** | Column_of_Pedro_IV |

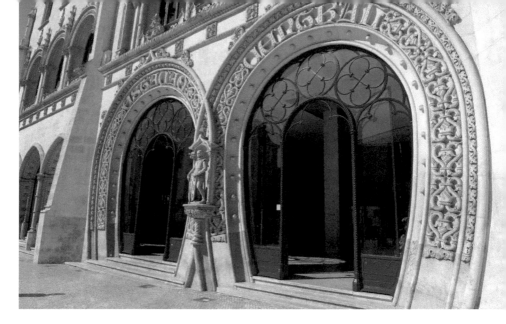

## Rossio Train Station (Estação do Rossio) off Rossio Square has two intertwined horseshoe portals.

Designed between 1886 and 1887 by Portuguese architect José Luís Monteiro, the station was formerly known as Estação Central (Central Station) and that designation still appears in its façade. Trains reach the station through a tunnel which is more than 2.6 km (1.6 miles) long.

The Neo-Manueline façade dominates the northwest side of the square and is a Romantic recreation of the exuberant Manueline style, typical of early 16th century Portugal.

| ✉ **Addr:** | Rua 1 de Dezembro, 1249-970 Lisbon | ♥ **Where:** | 38.7144747 -9.1406196 | |
|---|---|---|---|---|
| ❓ **What:** | Train station | ⏱ **When:** | Morning | |
| 👁 **Look:** | West-southwest | W **Wik:** | Rossio_railway_station | |

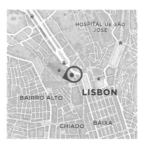

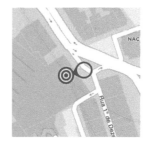

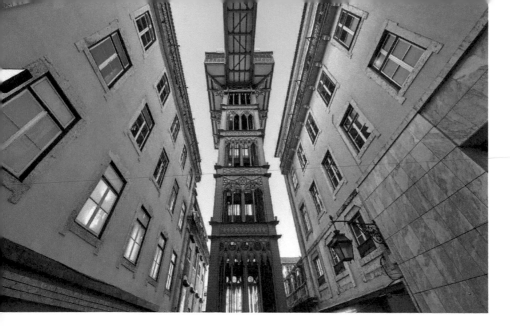

**Santa Justa Lift** (Elevador de Santa Justa), also called Carmo Lift (Elevador do Carmo), is a Neo-Gothic style iron elevator, or lift, in the civil parish of Santa Justa connecting the lower streets of the Baixa with the higher Largo do Carmo (Carmo Square).

Proposed in 1874, the elevator first operated in 1902, and is the only remaining vertical lift in the city.

With a height of 45 metres, covering seven stories, the tower includes two elevator cabins. On the top floor is a kiosk and lookout, with panoramic views of the city, plus two spiral staircases.

| ✉ **Addr:** | R. de Santa Justa 98, 1100-062 Lisboa | ♥ **Where:** | 38.712217 -9.139025 | |
|---|---|---|---|---|
| ❓ **What:** | Elevator | 🕐 **When:** | Morning | |
| 👁 **Look:** | West-southwest | Ⓦ **Wik:** | Santa_Justa_Lift | |

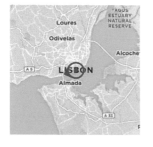
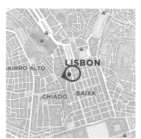

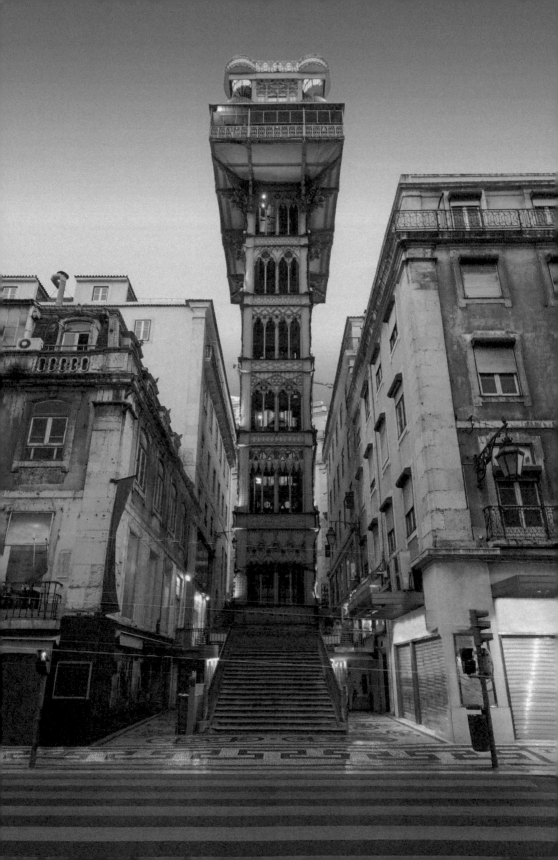

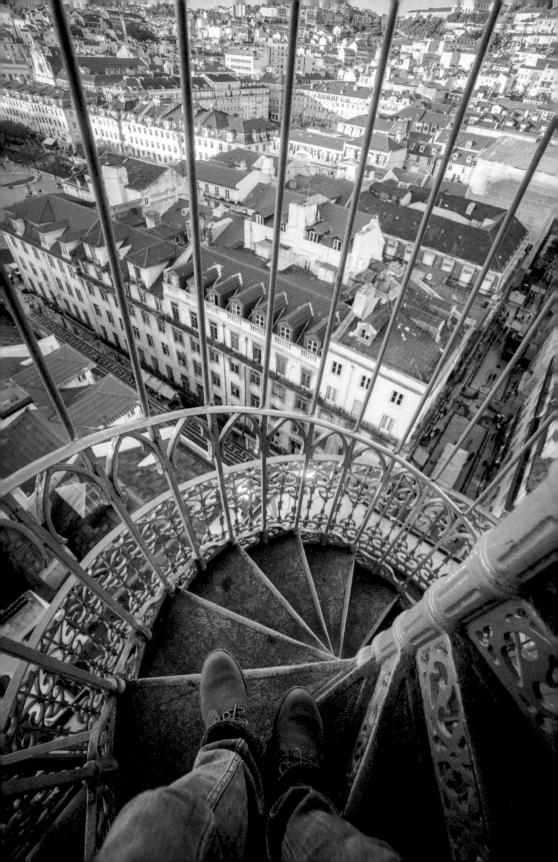

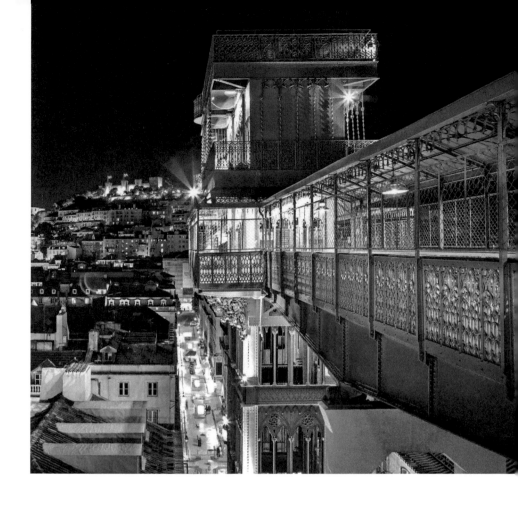

| ✉ **Addr:** | Rua do Carmo 69, 1200-091 Lisbon | ♀ **Where:** | 38.712083 -9.139714 |
| --- | --- | --- | --- |
| ❓ **What:** | Bridge | 🕐 **When:** | Anytime |
| 👁 **Look:** | East-northeast | ↔ **Far:** | 28 m (92 feet) |

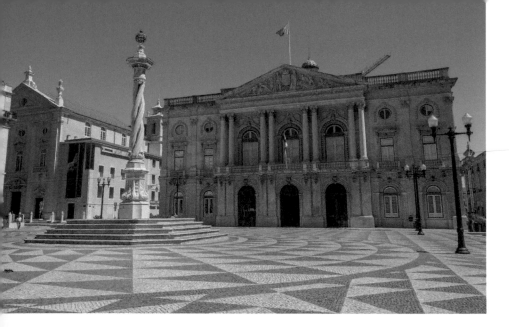

## Lisbon City Hall (Paços do Concelho de Lisboa) is the seat of the Lisbon municipal government. The neoclassical building in the City Square (Praça do Município) features a monumental façade with a large pediment over a central balcony.

Perhaps to encourage residents to pay their taxes, the city hall faces an old punishment post, the Pillory of Lisbon.

| ✉ **Addr:** | Praça do Município S/N, Lisboa | ♀ **Where:** | 38.707829 -9.13926 |  |
|---|---|---|---|---|
| ❓ **What:** | City hall | ◑ **When:** | Afternoon | |
| 👁 **Look:** | East-northeast | Ⓦ **Wik:** | Lisbon_City_Hall | |

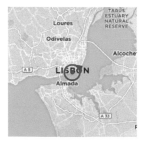
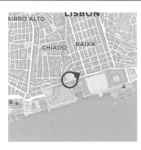
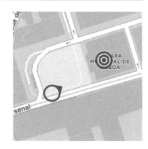

# Pillory of Lisbon

(Pelourinho de Lisboa) is a triple-twist column made in the 18th century from a single block of marble. Originally it had an iron crosspiece with hooks used for punishment by public humiliation, but today it is crowned by a gilt metal armillary sphere.

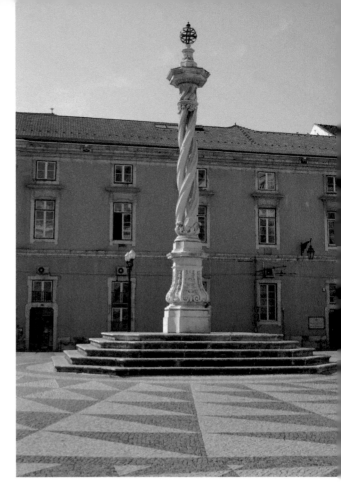

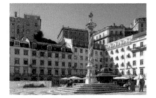

| <span>✉</span> **Addr:** | Praça do Município 32, 1200-005 Lisboa | <span>📍</span> **Where:** | 38.70806 -9.13917 |
|---|---|---|---|
| <span>❓</span> **What:** | Pillory | <span>🕐</span> **When:** | Afternoon |
| <span>👁</span> **Look:** | North | W **Wik:** | Pillory_of_Lisbon |

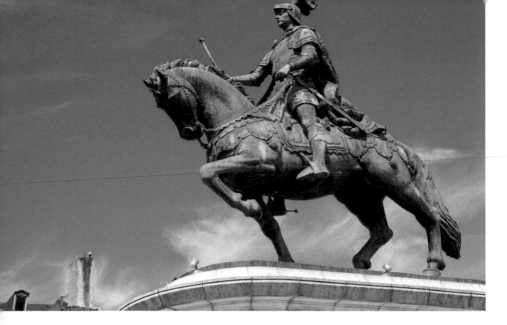

**King John I** (Dom João I) is a bronze equestrian statue by sculptor Leopoldo de Almeida from 1971. The monument carries medallions with the effigies of Nuno Álvares Pereira and João das Regras, two key characters in the 1385 Revolution that brought John I (1357-1433) to power.

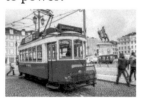

The statue is at one corner of Praça da Figueira (Square of the Fig Tree), near the tram line.

| ✉ **Addr:** | Praça da Figueira 5C, 1100-197 Lisbon | ♀ **Where:** | 38.713609 -9.137871 |
|---|---|---|---|
| ❷ **What:** | Equestrian statue | ◑ **When:** | Morning |
| 👁 **Look:** | West-southwest | W **Wik:** | Praça_da_Figueira |

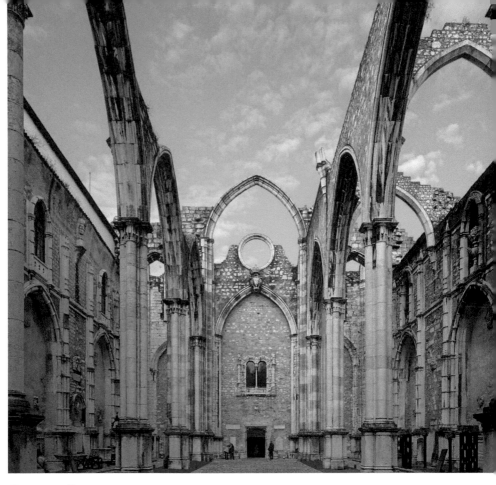

**Carmo Convent** (Convent of Our Lady of Mount Carmel, Convento da Ordem do Carmo) has a ruined Gothic church, open to the sky. Built 1389-1423, the stone roof over the nave collapsed during the 1755 earthquake and was never rebuilt.

| ✉ **Addr:** | Largo do Carmo, 1200-092 Lisbon | ♀ **Where:** | 38.712011 -9.140618 |
| --- | --- | --- | --- |
| ❷ **What:** | Museum | ⊙ **When:** | Afternoon |
| 👁 **Look:** | East-northeast | W **Wik:** | Carmo_Convent_(Lisbon) |

 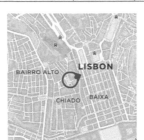 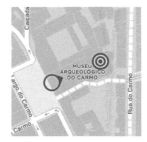

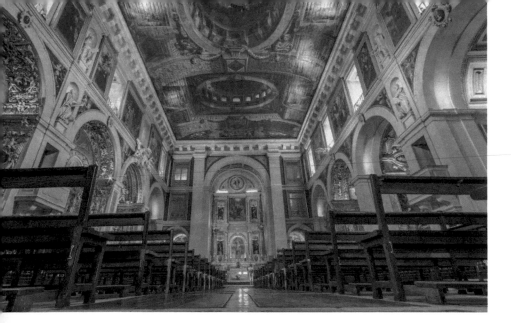

## Saint Roch Church

**Saint Roch Church** (Igreja de São Roque) is one of the earliest Jesuit churches, and one of the few buildings in Lisbon to survive the earthquake relatively unscathed. When built in the 16th century it was the first Jesuit church designed in the "auditorium-church" style specifically for preaching.

The painted ceiling of the nave is a *trompe l'oei* designed to give the illusion of barrel vaulting supported by four large arches covered in volutes, painted between 1584 and 1586 by Francisco Venegas.

| ✉ **Addr:** | Largo Trindade Coelho, 1200-470 Lisbon | ♥ **Where:** | 38.713435 -9.143411 |
|---|---|---|---|
| ❷ **What:** | Church | ☉ **When:** | Anytime |
| 👁 **Look:** | North | W **Wik:** | Igreja_de_São_Roque |

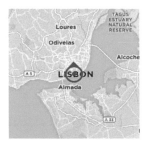
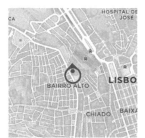
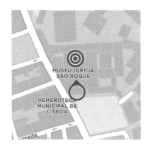

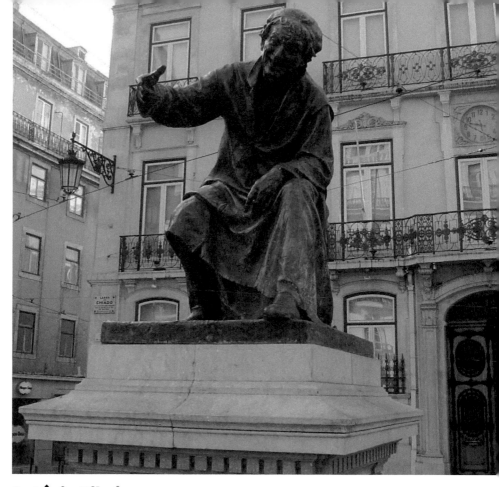

**António Ribeiro** is 1925 bronze statue in Chiado Square of the popular poet (c.1520–1591) who lived in the area and whose nickname was "chiado" ("squeak").

| | | | |
|---|---|---|---|
| ✉ **Addr:** | R. Garrett Pl, 1200-094 Lisboa | ♥ **Where:** | 38.71059 -9.142218 |
| ❓ **What:** | Statue | ☾ **When:** | Afternoon |
| 👁 **Look:** | South | W **Wik:** | Chiado |

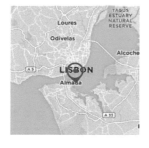
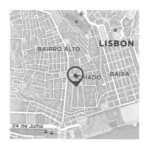

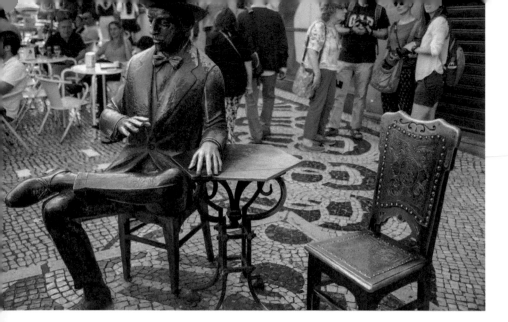

**Fernando Pessoa** is a bronze statue of one of the greatest poets in the Portuguese language. Pessoa was born in Lisbon in 1888 near this location (by the Opera House). He was a prolific writer, and wrote under his own name and over 75 others.

The statue is by Chiado Square at Café a Brasileira, one of the preferred places of Pessoa and his literary group during the 1910s.

| ✉ **Addr:** | R. Garrett 122, 1200-273 Lisbon | 📍 **Where:** | 38.710682 -9.142120 |
|---|---|---|---|
| ❷ **What:** | Statue | 🕐 **When:** | Afternoon |
| 👁 **Look:** | North | W **Wik:** | Fernando_Pessoa |

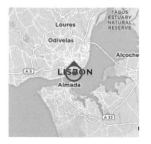
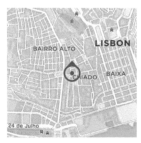
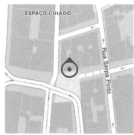

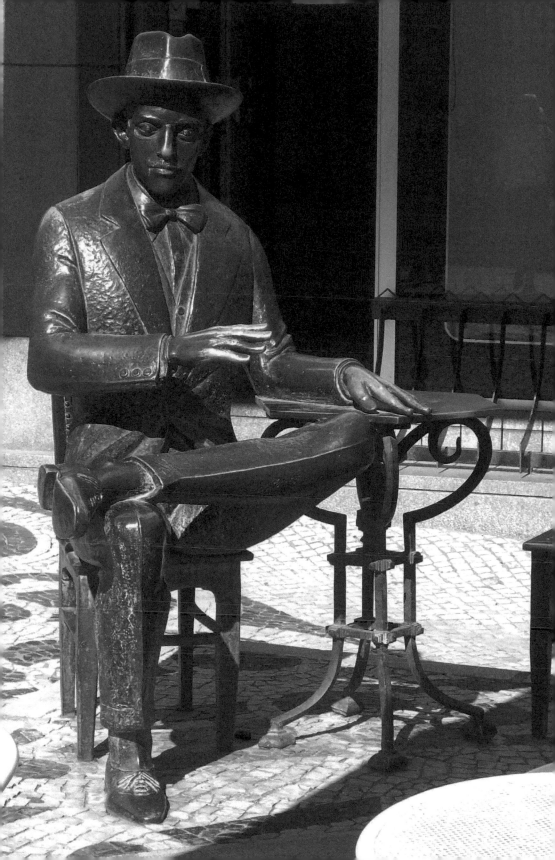

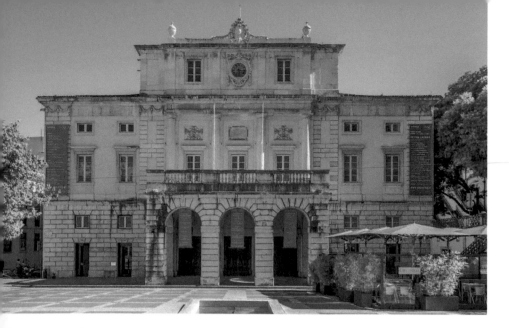

## Saint Charles National Theater (Teatro Nacional de São Carlos) is an opera house opened in 1793. The design by Portuguese architect José da Costa e Silva features neoclassical and rococo elements and was inspired by La Scala in Milan.

A theatre based on this one was built in Rio de Janeiro in the early 19th century, when the Portuguese Royal Court fled the invading Napoleonic troops and escaped to the Portuguese colony of Brazil.

This view is from Largo de São Carlos, near Chiado Square.

| ✉ **Addr:** | R. Serpa Pinto 9, 1200-442 Lisbon | ♀ **Where:** | 38.709977 -9.141749 |
| --- | --- | --- | --- |
| ❓ **What:** | Theater | ◑ **When:** | Afternoon |
| 👁 **Look:** | South | W **Wik:** | Teatro_Nacional_de_São_Carlos |

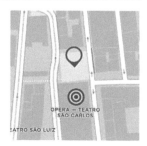

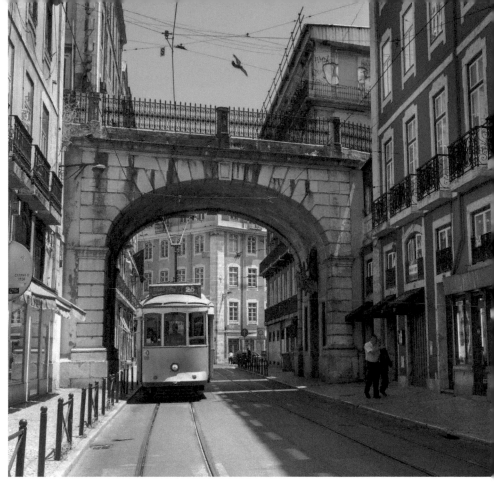

**Saint Paul Street** (Rua de Sao Paulo) has a bridge at Rua do Alecrim which frames a shot of a passing tram. This bridge is a continuation of the bridge over the adjacent pink street, Rua Nova do Carvalho.

| ✉ **Addr:** | Rua de Sao Paulo 58, 1200-014 Lisbon | ♀ **Where:** | 38.70758 -9.143775 | |
|---|---|---|---|---|
| ◑ **When:** | Afternoon | ◉ **Look:** | East-southeast | |
| ↔ **Far:** | 30 m (110 feet) | | | |

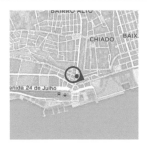
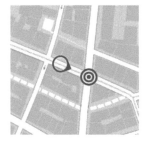

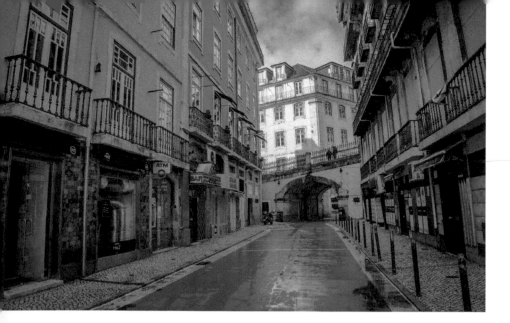

**Pink Street** (Rua Nova do Carvalho, known locally as Rua Cor-de-Rosa) is an Instagram-friendly pink pathway that beckons your camera. At the mid-point is a yellow bridge which you can photograph from the east (above) or west (next page).

Located near the old port, the Cais do Sodré neighborhood was Lisbon's red-light district. But the area was gentrified in 2011 with cafes, bars and a road of toned-down red.

Nearby is Pensão Amor (at Rua do Alecrim 19) with colorful graffiti murals and scarlet walls.

| ✉ **Addr:** | Rua Nova do Carvalho, Lisbon | ♀ **Where:** | 38.707213 -9.14306 |
|---|---|---|---|
| ❓ **What:** | Street | ◐ **When:** | Morning |
| 👁 **Look:** | West-southwest | ↔ **Far:** | 40 m (110 feet) |

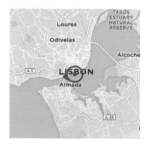
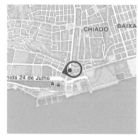

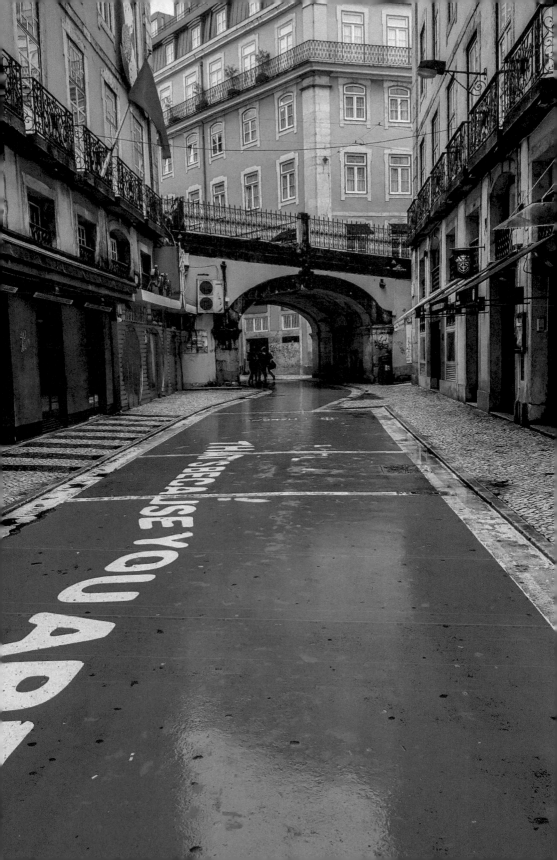

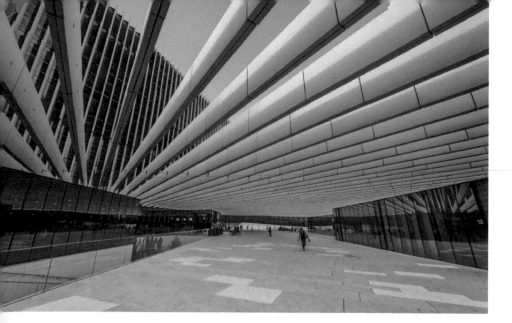

**EDP headquarters** features a photographic courtyard between two buildings. You can use these leading lines for striking and dynamic shots.

Energias de Portuga (EDP) is an electricity generating and distribution company founded in 1976. The headquarters were designed by Lisbon-based architects and brothers Francisco and Manuel Aires Mateus and opened in 2015.

| ✉ **Addr:** | Av. 24 de Julho 12, 1200-109 Lisbon | ♀ **Where:** | 38.7068 -9.148932 |
|---|---|---|---|
| ❓ **What:** | Building | 🕐 **When:** | Morning |
| 👁 **Look:** | Northwest | W **Wik:** | Energias_de_Portugal |

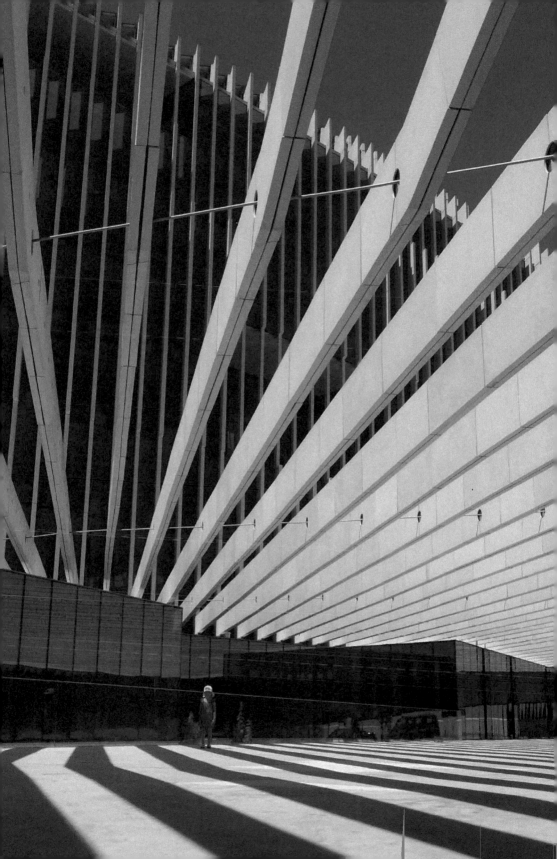

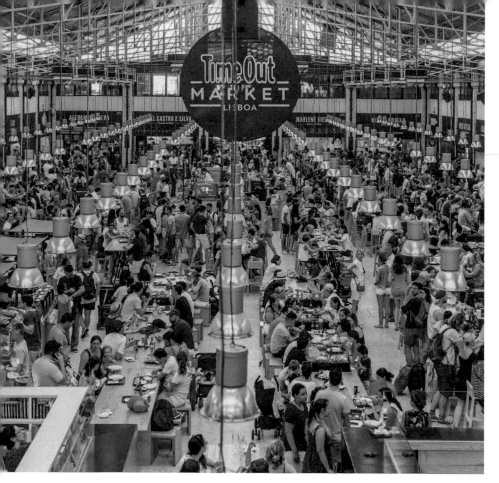

**Time Out Market Lisboa** is a food hall located in the Mercado da Ribeira at Cais do Sodre. Opened 2014, the market provides welcome refreshments for the weary photographer.

| ✉ **Addr:** | Av. 24 de Julho 49, 1200-479 Lisboa | ♀ **Where:** | 38.707082 -9.145898 |
| --- | --- | --- | --- |
| ❓ **What:** | Food hall | ◗ **When:** | Anytime |
| 👁 **Look:** | North | W **Wik:** | Time_Out_Market_Lisboa |

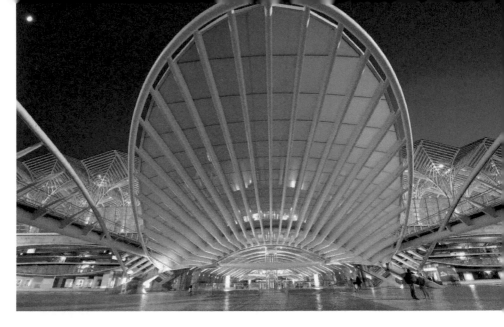

**East Station** (Gare do Oriente) is a modernist train station in Lsibon's civil parish of Parque das Nações.

Designed by Spanish architect Santiago Calatrava and opened in 1998, the complex includes a high-speed commuter and regional train hub, a Lisbon Metro station, a local, national and international bus station, a shopping centre and a police station.

| ✉ **Addr:** | Av. Dom João II MB, 1990-084 Lisboa | ♀ **Where:** | 38.767742 -9.09792 |
| --- | --- | --- | --- |
| ❓ **What:** | Railway station | ◑ **When:** | Anytime |
| 👁 **Look:** | West | Ⓦ **Wik:** | Gare_do_Oriente |

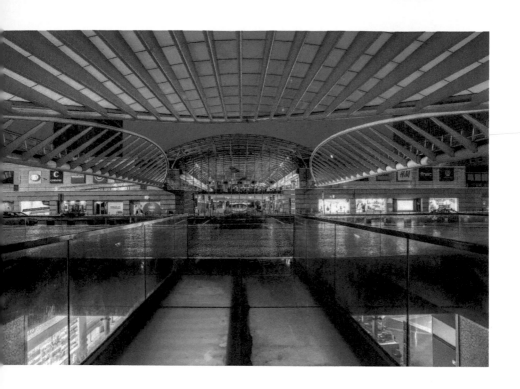

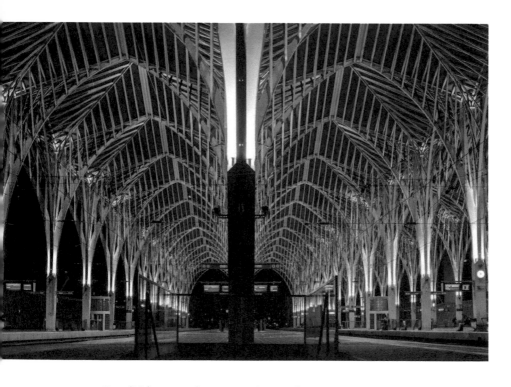

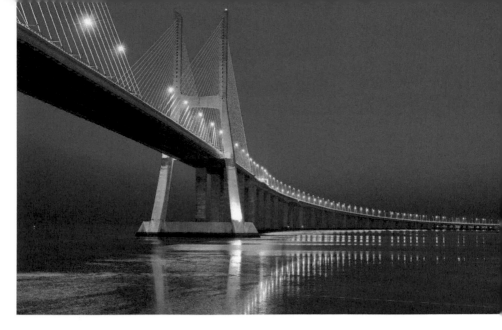

## Vasco da Gama Bridge

**Vasco da Gama Bridge** (Ponte Vasco da Gama) is a cable-stayed bridge flanked by viaducts and rangeviews that spans the Tagus River in Parque das Nações. With a total length of 12.3 km (7.6 mi), this is the longest bridge entirely within Europe.

The bridge was opened to traffic on 29 March 1998, just in time for Expo 98, the World's Fair that celebrated the 500th anniversary of the discovery by Vasco da Gama of the sea route from Europe to India.

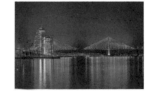

This dusk shot is from Jardim do Passeio dos Heróis do Mar.

| ✉ **Addr:** | | 📍 **Where:** | 38.785040 -9.091540 |
| --- | --- | --- | --- |
| ❓ **What:** | Bridge | 🕐 **When:** | Anytime |
| 👁 **Look:** | East | W **Wik:** | Vasco_da_Gama_Bridge |

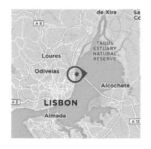

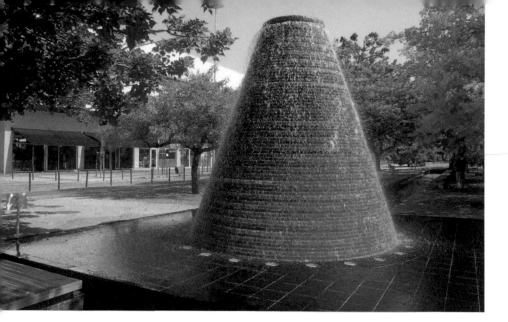

**Volcano Fountains** (Water Volcanoes, Fuente Ornamental) are six fountains along "Alameda dos Oceanos" boulevard, connected by a water channel.

Each "volcano" is a 4-meter-high cone covered in colorful tiles ranging from red to green. They erupt with water every 25 seconds for a total of 1,600 eruptions per day.

Park of the Nations (Parque das Nações) is the most northeastern civil parish of Lisbon. Site of Expo '98, the area is a wealth of modern architecture and attractions.

| ✉ **Addr:** | Alameda dos Oceanos, 1990-221 Lisbon | ♀ **Where:** | 38.7629032 -9.096071 |  |
|---|---|---|---|---|
| ❓ **What:** | Fountain | ◑ **When:** | Morning | |
| 👁 **Look:** | West-northwest | ↔ **Far:** | 6 m (20 feet) | |

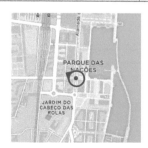

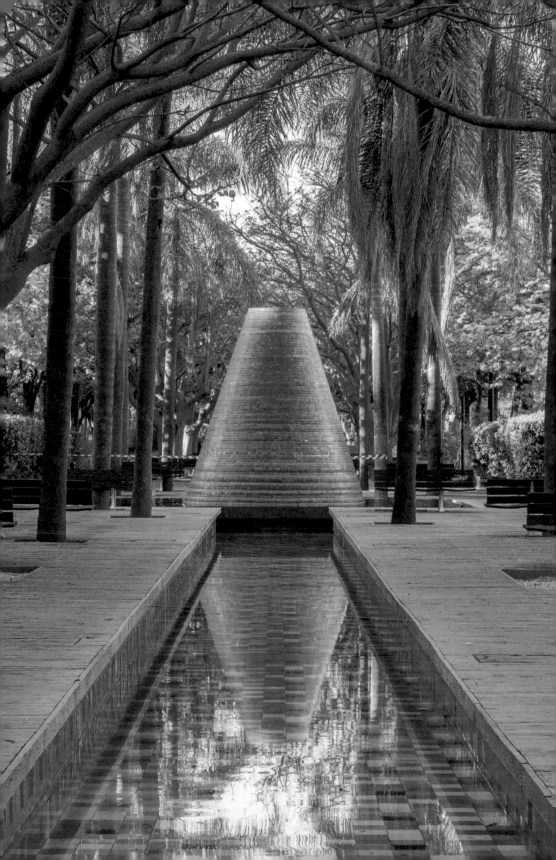

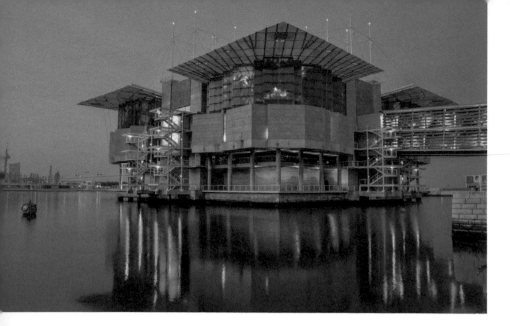

## Lisbon Oceanarium (Oceanário de Lisboa) is the largest indoor aquarium in Europe.

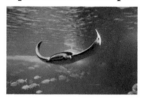

Built on a pier in an artificial lagoon, the Oceanarium was designed by U.S. architect Peter Chermayeff.

The main exhibit is a five million liter (1.3 million US gal) tank with four large 49 m2 (530 sq ft) acrylic windows on its sides.

Shooting through the windows of the 7 m (23 feet) deep pool, you can appear to be underwater, swimming with the sharks and rays.

| ✉ **Addr:** | Esplanada Dom Carlos I, 1990-005 Lisbon | ♀ **Where:** | 38.762773 -9.0946981 |
|---|---|---|---|
| ❷ **What:** | Oceanarium | ◑ **When:** | Anytime |
| ⬤ **Look:** | Northeast | W **Wik:** | Lisbon_Oceanarium |

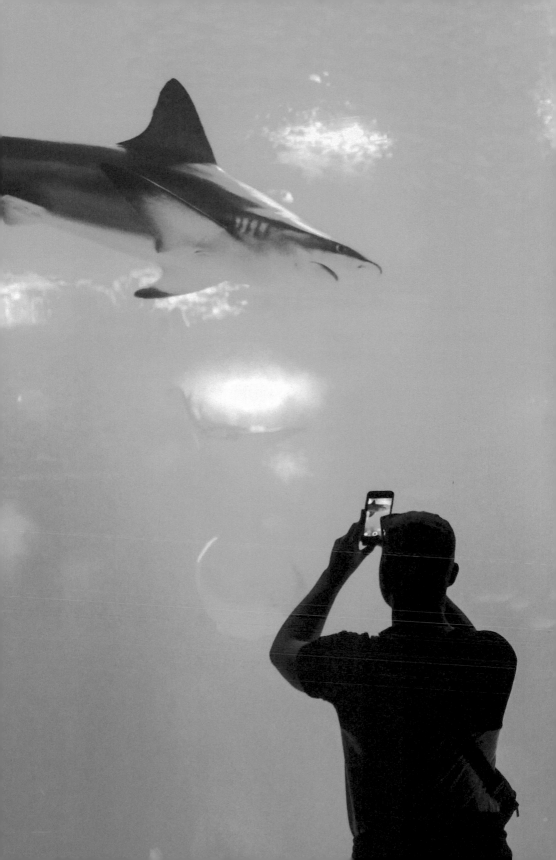

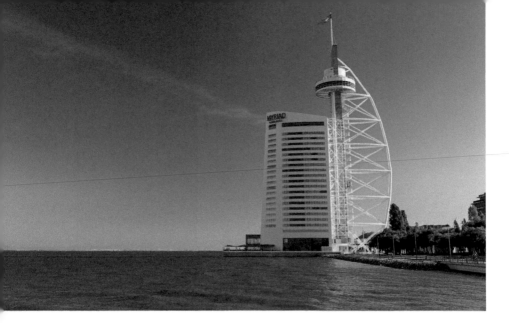

**Vasco da Gama Tower** (Torre Vasco da Gama) is a 145-meter (476 ft) lattice tower and Lisbon's tallest building. The tower was built in 1998 for the Expo '98 World's Fair and its sail-shape is similar to the Burj Al Arab hotel in Dubai. There is an observation deck at the top but it has been closed for many years.

Adjacent and attached is the Myriad five-star hotel, added in 2012.

| ✉ **Addr:** | Torre Vasco da Gama, 1990-173 Lisboa | ♀ **Where:** | 38.777247 -9.090843 |
|---|---|---|---|
| ❷ **What:** | Tower | ☾ **When:** | Morning |
| 👁 **Look:** | South | W **Wik:** | Vasco_da_Gama_Tower |

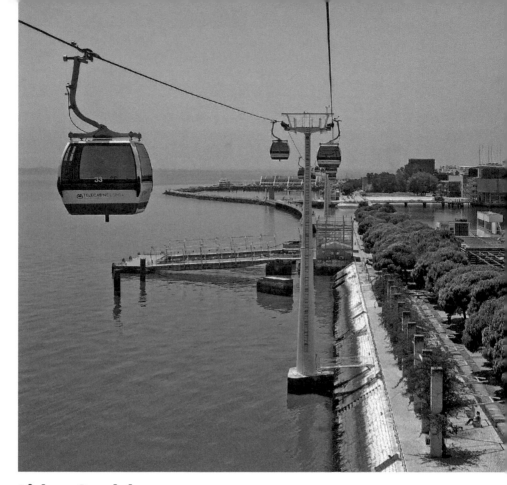

**Lisbon Gondola** (Telecabine Lisboa) is a gondola ride 30m over Tagus River, connecting the Oceanarium to Vasco da Gama Tower. Inaugurated in 1998 for the International Exposition of Lisbon (EXPO'98), the gondola has 40 closed cabins and travels 1,230 meters.

| ✉ **Addr:** | Passeio das Tágides, 1990-280 Lisboa | ♀ **Where:** | 38.773349 -9.091397 |
|---|---|---|---|
| ❷ **What:** | Gondola | ☽ **When:** | Morning |
| 👁 **Look:** | South | ↔ **Far:** | 60 m (200 feet) |

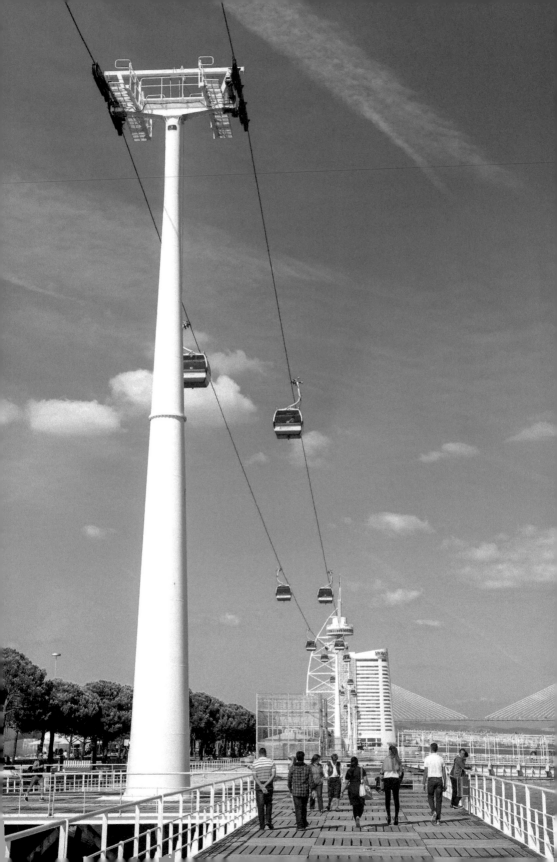

**Sun-Man** (Homem Sol) is a 1998 sculpture by Lisbon-born Jorge Vieira. The three-legged man is 20 meters tall with six arms that resemble fish bodies.

| ✉ **Addr:** | Alameda dos Oceanos 10611A, 1990-203 Lisboa | ♀ **Where:** | 38.767604 -9.0955745 |
|---|---|---|---|
| ❓ **What:** | Sculpture | ⏱ **When:** | Anytime |
| 👁 **Look:** | Northwest | ↔ **Far:** | 2 m (7 feet) |

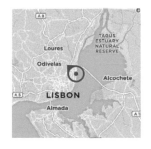
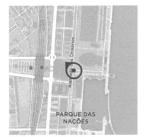

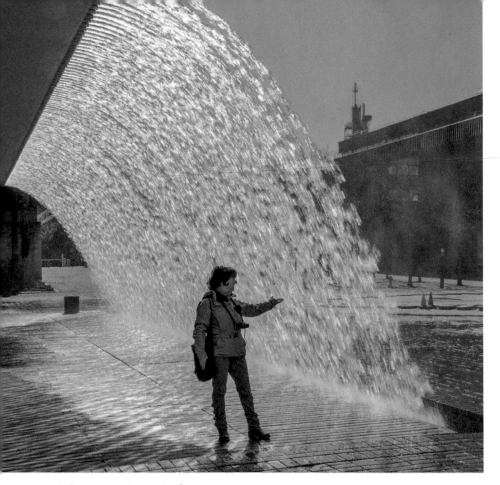

**Ulysses Fountain** (Fonte de Ulisses) is a man-made waterfall at Water Garden (Jardim da Água). In Roman times, Lisbon was named for the mythical Ulysses, who founded the settlement after he left Troy.

| ✉ **Addr:** | | ♀ **Where:** | 38.7616659 -9.0937262 | |
|---|---|---|---|---|
| ❓ **What:** | Fountain | ◑ **When:** | Morning | |
| 👁 **Look:** | South | ↔ **Far:** | 22 m (72 feet) | |

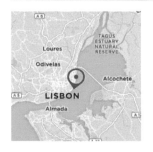
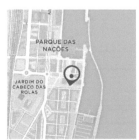
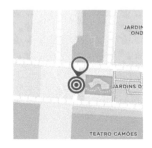

**Acrobats** (Rizoma) is a sculpture of balancing figures by Antony Gormley.

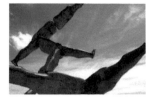

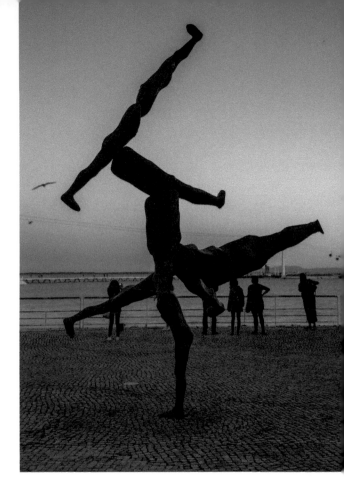

| ✉ **Addr:** | | ♀ **Where:** | 38.767078 |
|---|---|---|---|
| | | | -9.094601 |
| ❓ **What:** | Sculpture | ◑ **When:** | Anytime |
| 👁 **Look:** | Southeast | ↔ **Far:** | 15 m (49 feet) |

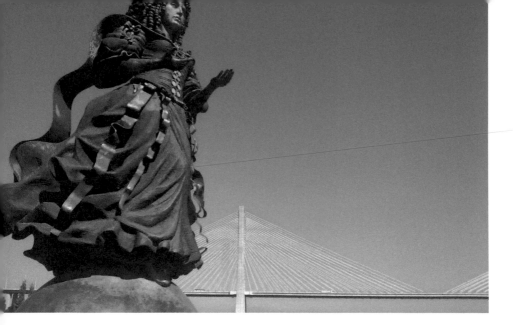

## Catherine of Braganza (Rainha D. Catarina de Bragança) is a statue by Audrey Flack near the Vasco da Gama Bridge.

Catherine from the House of Braganza was the daughter of King John IV, who became the first king of Portugal in 1640 after overthrowing the rule of the Spanish Habsburgs over Portugal. She served as regent of Portugal during the absence of her brother in 1701 and during 1704–1705, after her return to her homeland as a widow.

| ✉ **Addr:** | Passeio do Tejo, Lisbon | ♀ **Where:** | 38.781401 -9.091072 |
|---|---|---|---|
| ❓ **What:** | Sculpture | ⏱ **When:** | Afternoon |
| 👁 **Look:** | North-northeast | W **Wik:** | Catherine_of_Braganza |

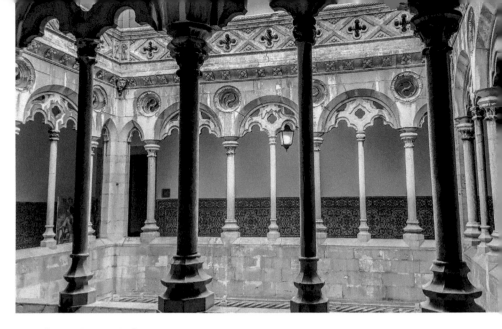

**National Azulejo Museum** (Museu Nacional do Azulejo), also known as The National Tile Museum, houses the largest collection of Portuguese tiles in the world. *Azulejos* are a form of Spanish and Portuguese painted tin-glazed ceramic tilework and still constitute a major aspect of Portuguese architecture as they are applied on walls, floors and even ceilings. Many azulejos chronicle major historical and cultural aspects of Portuguese history.

Established in 1965, the museum is housed in the former Convent of Madre Deus, founded by Queen D. Leonor in 1509. Of note are the 16th-century mannerist cloister and the Chapel of Saint Anthony and Choir.

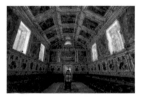

| ✉ **Addr:** | R. Me. Deus 1B, 1900-312 Lisboa | 📍 **Where:** | 38.724263 -9.114219 |
|---|---|---|---|
| ❓ **What:** | Museum | 🕐 **When:** | Anytime |
| 👁 **Look:** | West-northwest | W **Wik:** | National_Azulejo_Museum |

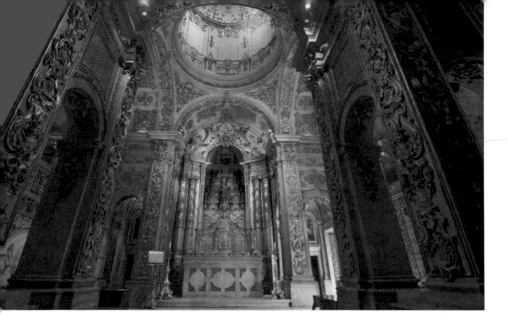

**Mother of God Church** (Madre de Deus Church) is part of the National Azulejo Museum. The side walls are decorated with beautiful blue-and-white azulejos tilework.

| ✉ **Addr:** | R. Me. Deus 1B, 1900-312 Lisboa | 📍 **Where:** | 38.724676 -9.113698 |
| --- | --- | --- | --- |
| ❓ **What:** | Church | 🕐 **When:** | Anytime |
| 👁 **Look:** | Northeast | Ⓦ **Wik:** | Igreja_da_Madre_de_Deus_(S%C3%A3o_Jo%C3%A3o) |

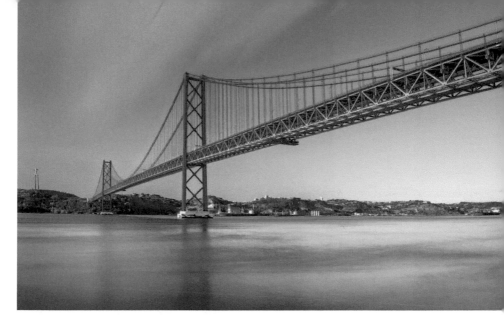

**25th of April Bridge** (Ponte 25 de Abril) is a suspension bridge crossing the Tagus River from Lisbon. The bridge is reminiscent of San Francisco's Golden Gate Bridge, being the same color, a similar design (about 10% smaller), and built by the American Bridge Company which constructed the San Francisco–Oakland Bay Bridge.

Opened in 1966, the name "25 de Abril" commemorates the Carnation Revolution, which overthrew the authoritarian regime of the Estado Novo.

| ✉ **Addr:** | IP7, 1300-472 Lisbon | ♀ **Where:** | 38.6984231 -9.1799412 |
|---|---|---|---|
| ❓ **What:** | Bridge | ◑ **When:** | Afternoon |
| 👁 **Look:** | South-southeast | W **Wik:** | 25_de_Abril_Bridge |

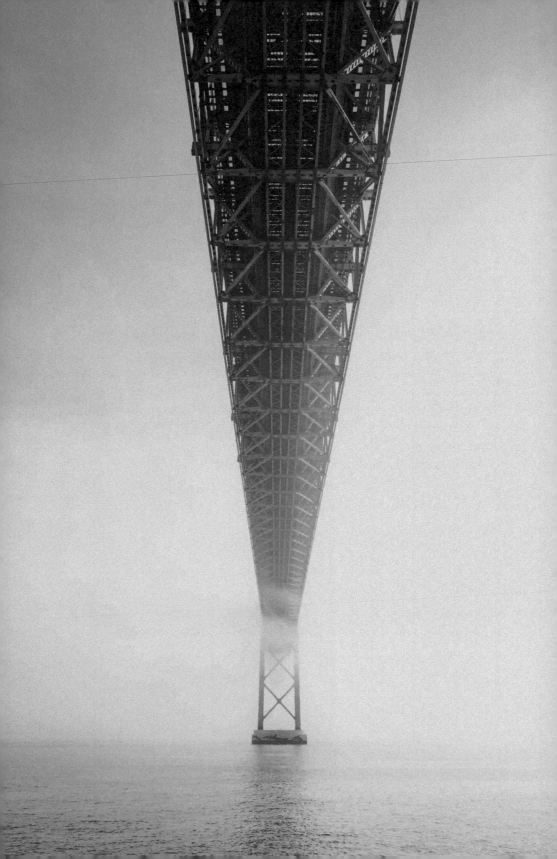

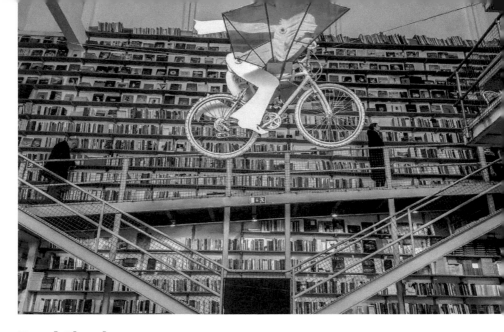

**Read Slowly** (Ler Devagar) was named the 15th most beautiful bookshop in the world by The Telegraph newspaper. Housed in a former printing factory, a flying bicycle hangs in front of a two-storey wall of books.

The bookstore is in the LX Factory area.

| ✉ **Addr:** | Rua Rodrigues Faria 103, 1300-501 Lisbon | 📍 **Where:** | 38.702687 -9.178313 |
|---|---|---|---|
| ❓ **What:** | Bookstore | 🌙 **When:** | Anytime |
| 👁 **Look:** | Northwest | ↔ **Far:** | 13 m (43 feet) |

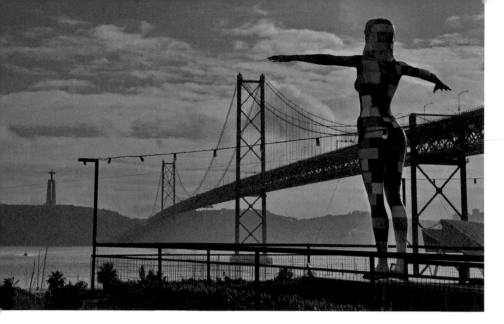

**Rio Maravilha** is a rooftop cafe with a giant statue of a woman mirroring the statue of Christ the King on the opposite side of the river.

The restaurant is part of LX Factory (LXF) in Alcântara, Lisbon's trendiest quarter, at a former 1846 industrial site now populated with galleries and design shops.

| | | | |
|---|---|---|---|
| ✉ **Addr:** | Rua Rodrigues de Faria 103, 1300-501 Lisboa | ♀ **Where:** | 38.701679 -9.178028 |
| ❓ **What:** | Sculpture | ◑ **When:** | Morning |
| 👁 **Look:** | South | ↔ **Far:** | 3 m (10 feet) |

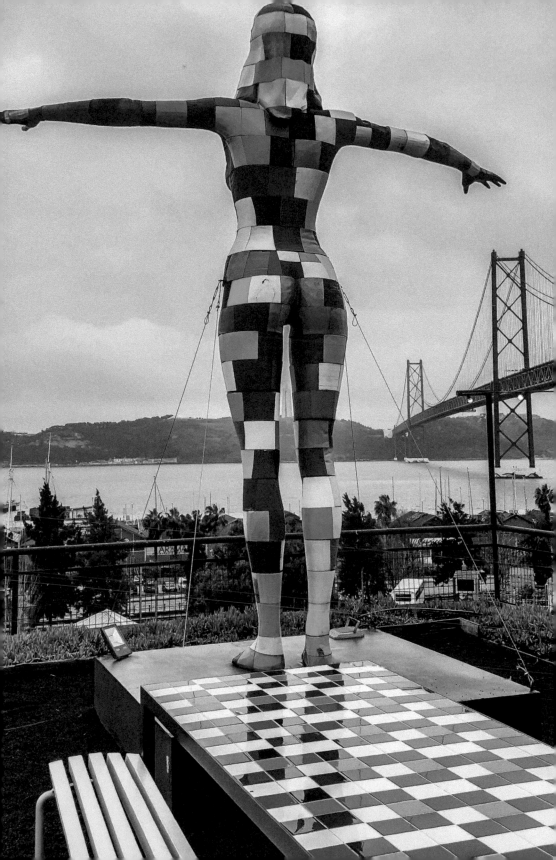

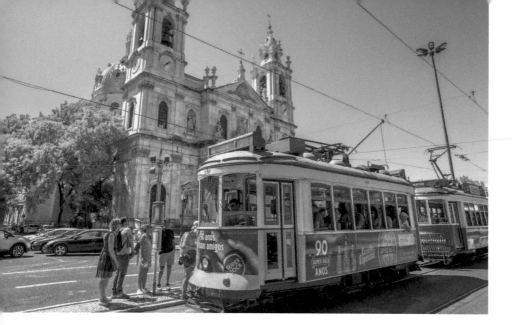

## Estrela Basilica (Basílica da Estrela), or Royal Basilica and Convent of the Most Sacred Heart of Jesus, is a basilica and ancient carmelite convent.

Built 1779 to 1790, the church has a giant dome and twin bell towers. Carris route 28E passes outside.

| | | | |
|---|---|---|---|
| ✉ **Addr:** | Praça da Estrela 53, 1200-667 Lisboa | ♀ **Where:** | 38.7137103 -9.1599818 |
| ❓ **What:** | Cathedral | ☽ **When:** | Morning |
| 👁 **Look:** | Southwest | W **Wik:** | Estrela_Basilica |

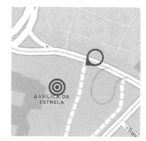

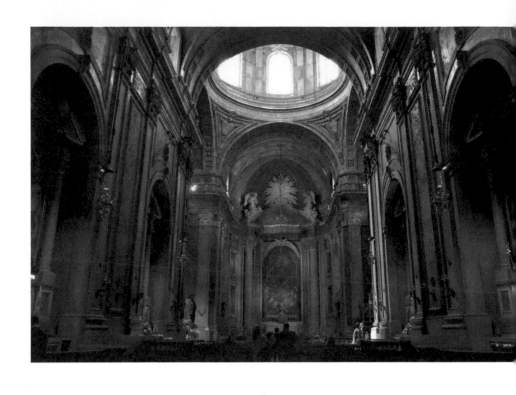

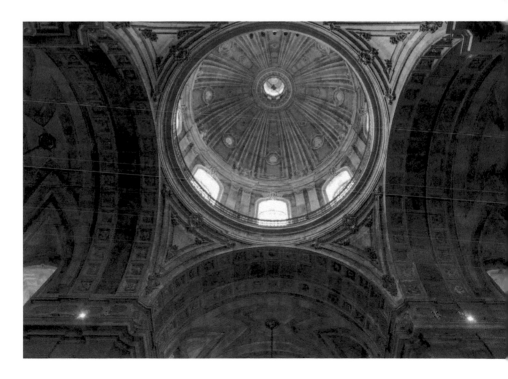

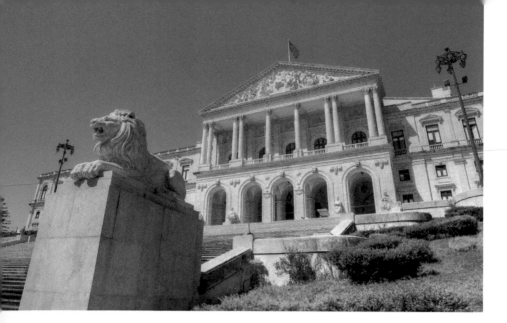

**Saint Benedict Palace** (Palácio de São Bento) is the home of the Assembly of the Republic, the Portuguese parliament. The site was originally a monastery dating to 1598. After the Liberal Revolution (1820) and the suppression of religious orders in Portugal (1834), the monks were expelled from the monastery and the Portuguese Parliament was installed in the building. The present neoclassical facade was added around 1903.

Nearby is São Bento Mansion, an 1877 villa within the garden of the old monastery and the Prime Minister's official residence since 1938.

| ✉ **Addr:** | R. Imprensa à Estrela 6, 1200-619 Lisbon | ♀ **Where:** | 38.712458 -9.152913 |  |
|---|---|---|---|---|
| ❓ **What:** | Palace | ◑ **When:** | Morning | |
| 👁 **Look:** | West | Ⓦ **Wik:** | São_Bento_Palace | |

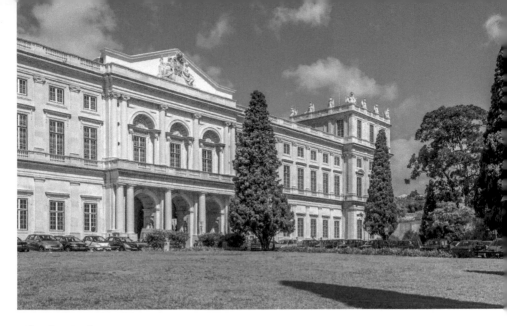

**Ajuda Palace** (Palácio da Ajuda) is a former royal residence. Begun in 1796, it is one of the earliest neoclassical buildings in Lisbon. The west wing is unfinished, leaving a lonely wall on one side of the courtyard (next page).

The photo above is of the main east entrance, at Largo Ajuda. Nearby is a monument to assassinated monarch King Carlos of Portugal.

| | | | |
|---|---|---|---|
| ✉ **Addr:** | Calçada Ajuda 268, 1300-011 Lisboa | ♀ **Where:** | 38.707164 -9.196882 |
| ❓ **What:** | Former royal residence | ◑ **When:** | Morning |
| 👁 **Look:** | Northwest | Ｗ **Wik:** | Palace_of_Ajuda |

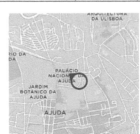
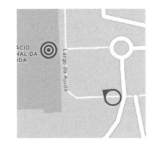

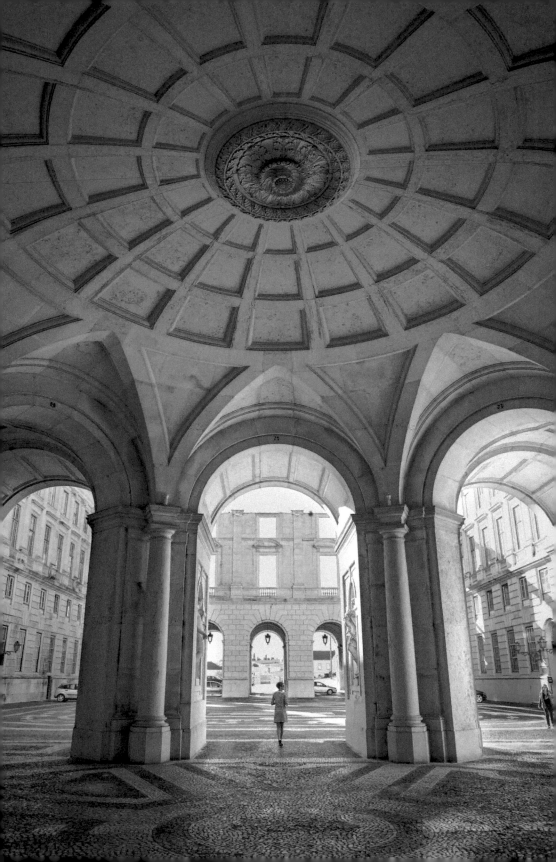

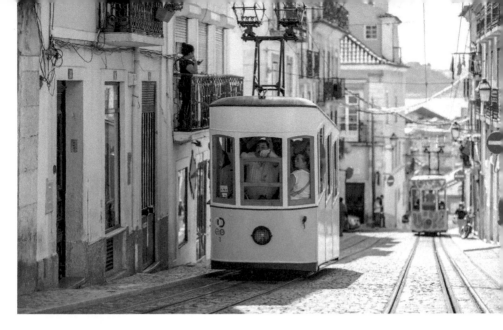

**Bica Funicular** (Ascensor da Bica), sometimes known as the Bica Elevator (Elevador da Bica), is a funicular railway line in the civil parish of Misericórdia. Two cars linked by a cable travel 245 metres (804 ft) simultaneously in opposite directions, linking Rua de São Paulo to Rua da Bica de Duarte Belo.

The tram started operation in 1892, originally using water weights, with the cars equipped with water tanks.

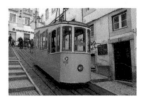

| ✉ **Addr:** | Rua de S. Paulo 236, 1200-006 Lisboa | ♀ **Where:** | 38.710765 -9.145812 |
|---|---|---|---|
| ❓ **What:** | Funicular railway | ⏱ **When:** | Morning |
| 👁 **Look:** | South-southwest | W **Wik:** | Ascensor_da_Bica |

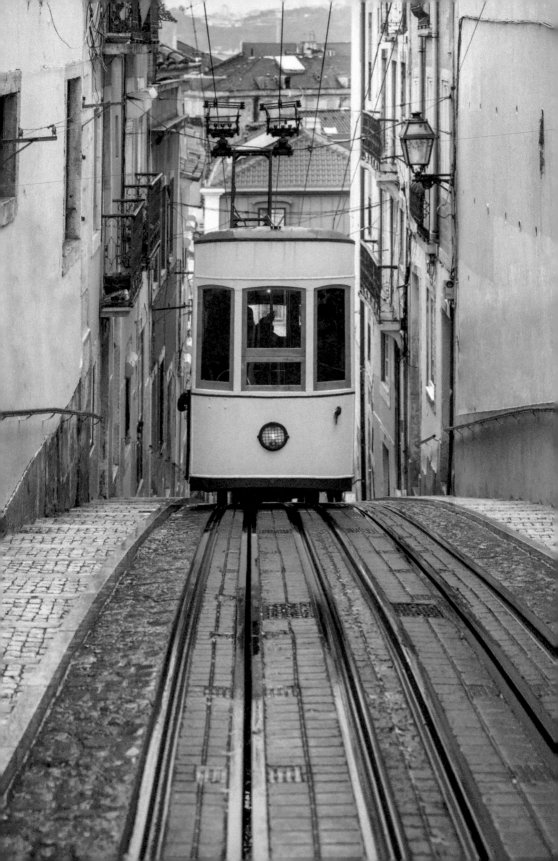

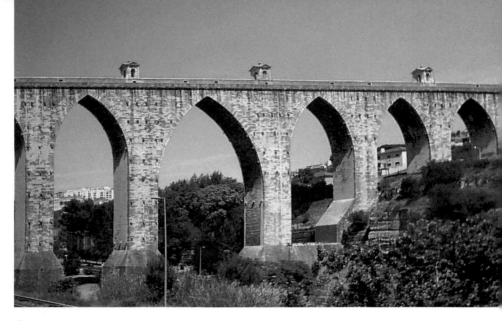

## Águas Livres Aqueduct (Aqueduto das Águas Livres, "Aqueduct of the Free Waters") is a historic aqueduct with an impressive span over the Alcantara valley.

Built to bring drinking water to Lisbon and completed in 1744, the main course of the aqueduct covers 18 km. The centerpiece span is this 941-meter-long elevated water channel. Gothic-like pointed arches reach 65 meters high.

| ✉ **Addr:** | Calçada da Quintinha 6, 1070-225 Lisbon | ♀ **Where:** | 38.7294713 -9.1719409 | |
|---|---|---|---|---|
| ❓ **What:** | Aqueduct | ⏲ **When:** | Afternoon | |
| 👁 **Look:** | East | W **Wik:** | Águas_Livres_Aqueduct | |

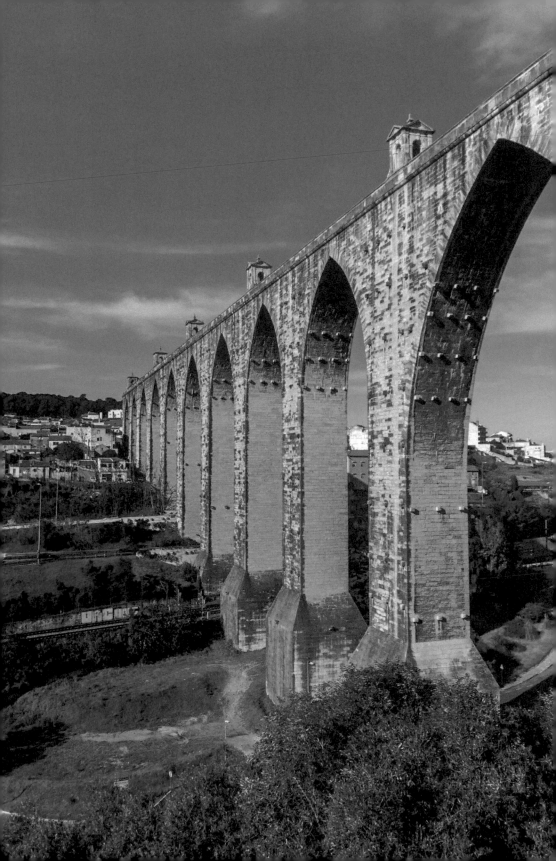

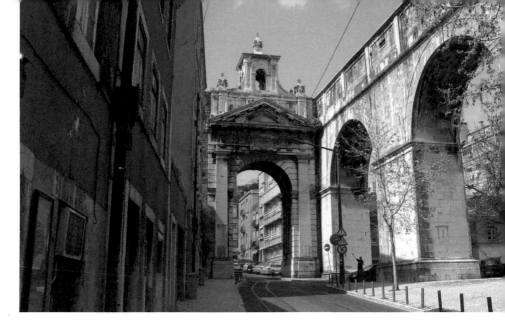

**Amoreiras Arch** is a commemorative arch built in the Amoreiras neighborhood in 1748, to celebrate the first water flowing to Lisbon.

Crossing Rua das Amoreiras near Largo Rato, the arch takes the water at a right angle to the nearby "Mãe d'Agua" (Mother of the Water) reservoir (pictured), the largest of the water reservoirs, which was finished in 1834.

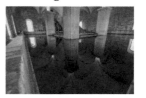

| ✉ **Addr:** | Rua Das Amoreiras Ao Rato, 1250-001 Lisbon | ♀ **Where:** | 38.7219507 -9.156876 |
|---|---|---|---|
| ❓ **What:** | Arch | ◑ **When:** | Morning |
| 👁 **Look:** | Northwest | ↔ **Far:** | 40 m (130 feet) |

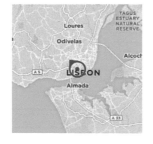
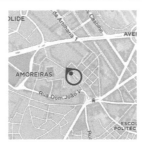

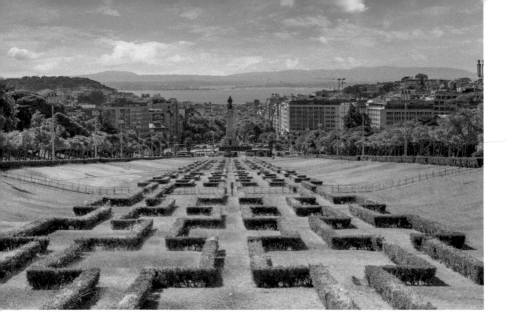

**Edward VII Park** (Parque Eduardo VII de Inglaterra) is a public park named for the English king who visited Portugal in 1902, to strengthen the relations between the two countries. Until that visit, its name was Liberty Park (Parque da Liberdade).

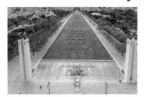

On the northern top of the park is a flagpole where the largest Flag of Portugal of the world is usually flown.

Viewed from Miradouro do Parque Eduardo VII.

| ✉ **Addr:** | Alameda Cardeal Cerejeira, 1070-051 Lisbon | ♀ **Where:** | 38.730452 -9.154508 |
| --- | --- | --- | --- |
| ❓ **What:** | Park | ◑ **When:** | Afternoon |
| 👁 **Look:** | Southeast | W **Wik:** | Eduardo_VII_Park |

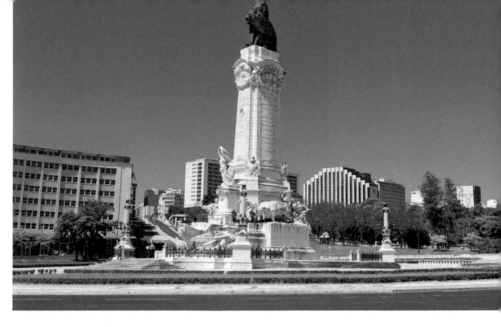

## Marquess of Pombal

**Marquess of Pombal** (Marquês de Pombal) is a monument to the powerful prime-minister who ruled Portugal from 1750 to 1777 and rebuilt coastal Lisbon after the disastrous 1755 Lisbon earthquake.

Standing at the center of an important traffic circle (Marquis of Pombal Square / Praça Marquês de Pombal), the column was built between 1917 and 1934 and is topped with a bronze statue of the Marquess with a lion by his side as a symbol of power.

| ✉ **Addr:** | Praça Marquês de Pombal, 1250-021 Lisbon | ♀ **Where:** | 38.7249089 -9.1502696 |
| --- | --- | --- | --- |
| ❓ **What:** | Monument | ⏱ **When:** | Afternoon |
| 👁 **Look:** | North-northeast | W **Wik:** | Marquis_of_Pombal_Square |

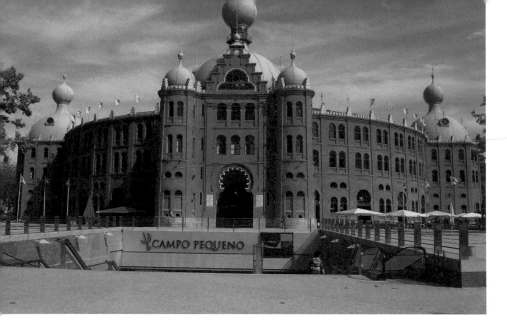

**Small Field Bullring** (Touros do Campo Pequeno) is the bullring of Lisbon. Built between 1890 and 1892 under the supervision of Portuguese architect António José Dias da Silva, the style is the neo-Mudéjar, a Romantic style inspired by the old Arab architecture from Iberia.

Unlike Spanish bullfighting, in Portugal the bull is not killed at the end of the fight. This was decreed by king Miguel of Portugal during his reign of 1828–1834 as he considered it inhumane to the animal.

| ✉ **Addr:** | Campo Pequeno D, 1000-082 Lisboa | ♀ **Where:** | 38.742393 -9.146418 | |
| --- | --- | --- | --- | --- |
| ❓ **What:** | Bullring | 🕐 **When:** | Afternoon | |
| 👁 **Look:** | East-northeast | W **Wik:** | Campo_Pequeno_bullring | |

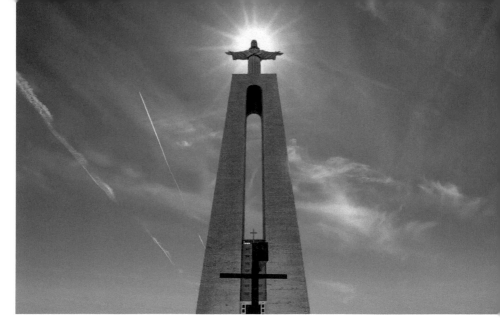

## Christuthe King (Cristo Rei) is a giant statue of Christ inspired by Christ the Redeemer (1931) of Rio de Janeiro, in Brazil.

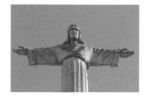

The monument overlooks Lisbon from across the river at the highest point of Almada, by the 25 de Abril Bridge. The statue is 28 m (92 feet) tall, on a 92 m (269 foot) pedestal. There is an observation deck at the top of the pedestal with panoramic views.

In 1934, Cardinal Patriarch of Lisbon visited Rio de Janeiro and saw the recently inaugurated statue of Christ the Redeemer (1931). Lisbon's version is two meters shorter as a statue but three times taller with the pedestal.

| ✉ **Addr:** | Av. Cristo Rei 63, Almada | 📍 **Where:** | 38.679302 -9.171328 |
| --- | --- | --- | --- |
| ❓ **What:** | Monument | 🕐 **When:** | Afternoon |
| 👁 **Look:** | South | W **Wik:** | Christ_the_King_(Almada) |

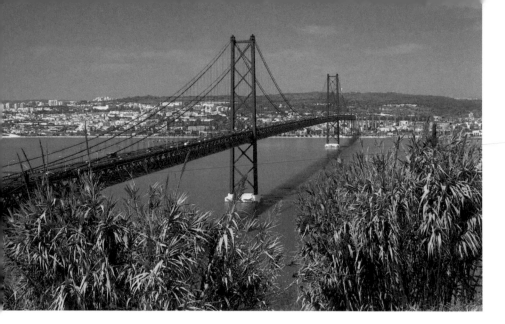

**Miradouro do Cristo Rei** (Viewpoint of Christ the King) is the highest point south of Lisbon, at an elevation of 104 m (341 ft), with a view of 25 de Abril Bridge and Lisbon.

| ✉ **Addr:** | 2800-058 Almada, Portugal | ♀ **Where:** | 38.679483 -9.171257 |
| --- | --- | --- | --- |
| ◑ **When:** | Morning | ◉ **Look:** | Northwest |
| ↔ **Far:** | 0.73 km (0.46 miles) | | |

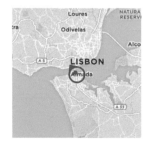

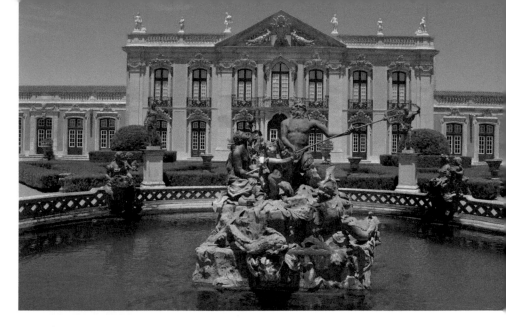

**Queluz Palace** (Palácio de Queluz) is an 18th-century palace known as the "Portuguese Versailles."

One of the last great Rococo buildings to be designed in Europe, the palace was conceived as a summer retreat for Dom Pedro of Braganza, later to become husband and then king consort to his own niece, Queen Maria I. It served as a discreet place of incarceration for Queen Maria as her descent into madness continued in the years following Dom Pedro's death in 1786.

Outside is Neptune's Glory, a sculptural fountain with tritons and dolphins which has been attributed to Bernini. Inside, rooms to photograph include the ballroom and the Hall of Ambassadors (Sala dos Embaixadores).

| ✉ **Addr:** | Largo Palácio de Queluz, 2745-191 Queluz | ♀ **Where:** | 38.750119 -9.25901 |
| --- | --- | --- | --- |
| ❓ **What:** | Palace | ◷ **When:** | Morning |
| 👁 **Look:** | North-northwest | W **Wik:** | Palace_of_Queluz |

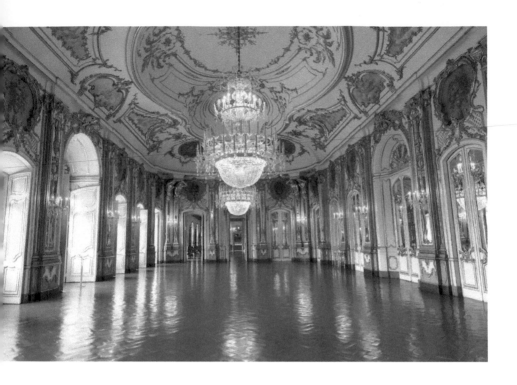

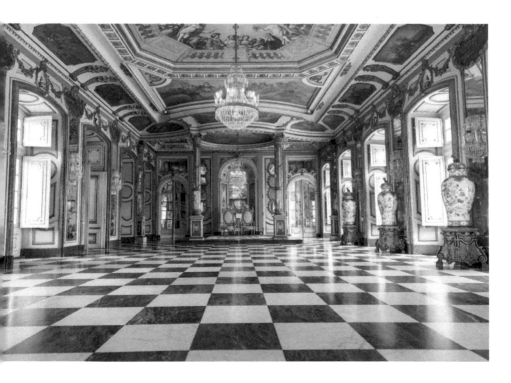

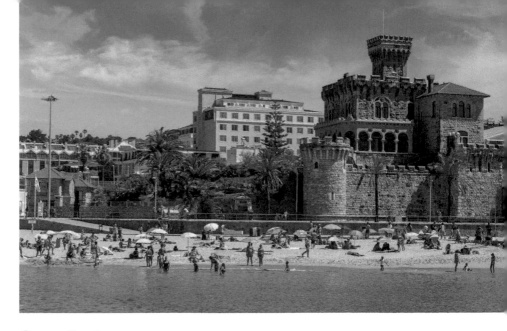

**Cross Fort** (Forte da Cruz) and Tamariz Beach (Praia do Tamariz) in Estoril. The solid fortifications around the area are a testament to the innumerable attacks by Spanish, French and English pirates and privateers.

Estoril is famed as a luxury entertainment destination on the Portuguese Riviera, as home of the Casino Estoril.

| ✉ **Addr:** | Av. Marginal PT, Estoril | ♀ **Where:** | 38.701508 -9.399104 | |
|---|---|---|---|---|
| ❷ **What:** | Fort | ◑ **When:** | Afternoon | |
| ◉ **Look:** | North-northeast | W **Wik:** | Estoril | |

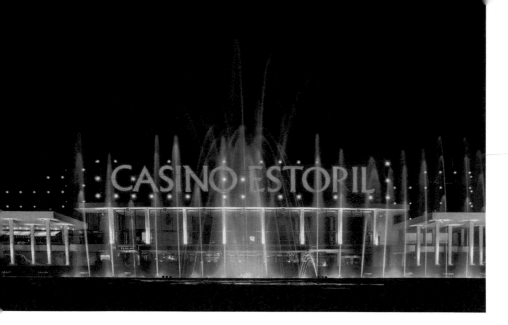

## Casino Estoril (Casino do Estoril) is one of the largest working casinos in Europe.

During the Second World War, when Lisbon was a neutral port, the Casino Estoril was reputed to be a gathering point for spies, dispossessed royals, and wartime adventurers; it became an inspiration for Ian Fleming's James Bond 007 novel Casino Royale.

| ✉ **Addr:** | Av. Dr. Stlanley Ho, 2765-190 Estoril | ♀ **Where:** | 38.706021 -9.397715 |
|---|---|---|---|
| ❓ **What:** | Casino | ◐ **When:** | Anytime |
| 👁 **Look:** | North-northeast | W **Wik:** | Casino_Estoril |

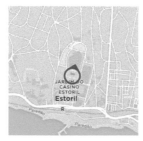
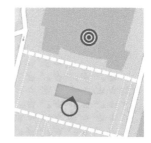

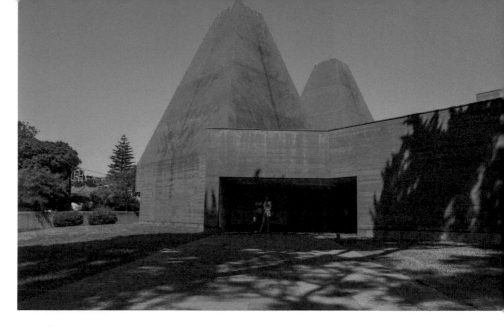

**Paula Rego Museum** (Casa das Histórias Paula Rego) displays the works of the artist Paula Rego. Designed by Eduardo Souto de Moura, the building has two pyramid-shaped towers and red-colored concrete. Previously existing mature trees of the park have been incorporated as elements in the design.

| ✉ **Addr:** | Av. da República 300, 2750-475 Cascais | ♀ **Where:** | 38.694951 -9.423891 |
| --- | --- | --- | --- |
| ❓ **What:** | Museum | ◑ **When:** | Morning |
| 👁 **Look:** | West | W **Wik:** | Casa_das_Histórias_Paula_Rego |

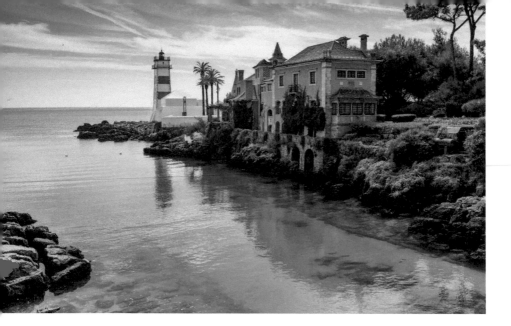

## Saint Martha Lighthouse (Farol de Santa Marta) is situated to the south of the centre of Cascais, on the estuary of the River Tagus, providing a light for the Cascais Bay and for the town's Marina. Dating from 1867, the lighthouse has a quadrangular masonry tower, 20 metres (66 ft) tall, covered with blue and white tiles and a red lantern.

| ✉ **Addr:** | Praceta Farol, 2750-642 Cascais | ♥ **Where:** | 38.691719 -9.421393 |
| **❓ What:** | Lighthouse | ◑ **When:** | Afternoon |
| 👁 **Look:** | South-southeast | W **Wik:** | Santa_Marta_Lighthouse_(Cascais) |

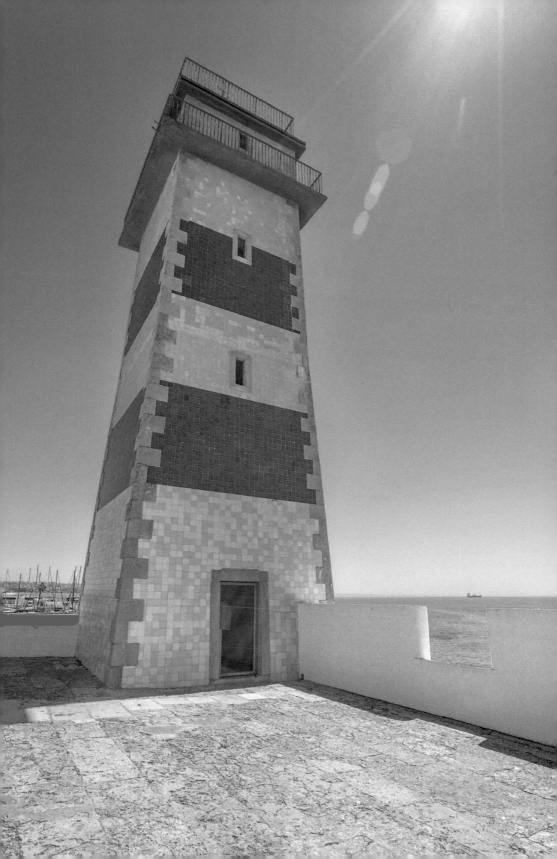

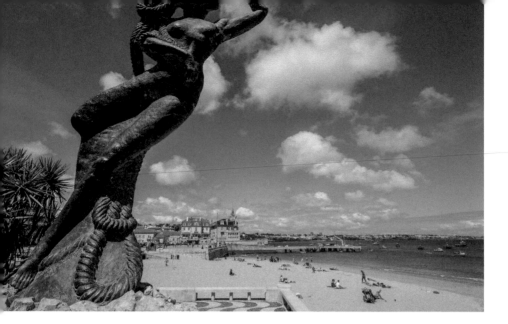

## Monument to the Portuguese Discoveries (Monumento aos Descobrimentos Portugueses) is a statue of a mermaid to protect the fishermen of Cascais. The mermaid overlooks Ribeira Beach (Praia de Ribeira).

| ✉ **Addr:** | Praia da Ribeira de Cascais, 2750-427 Cascais | ♀ **Where:** | 38.696499 -9.420269 |
| --- | --- | --- | --- |
| ❓ **What:** | Statue | ◑ **When:** | Afternoon |
| 👁 **Look:** | East | ↔ **Far:** | 7 m (23 feet) |

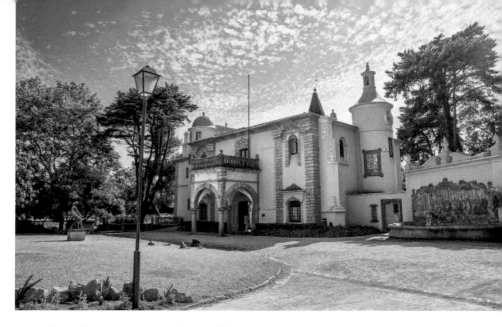

## Condes de Castro Guimarães Museum, originally known as the "Torre de S. Sebastião" (Saint Sebastian Tower), was built in 1900 as an aristocrat's summer residence.

Designed by Francisco Vilaça for Jorge O'Neil, a Portuguese / Irish aristocrat, the building employs several architectural styles, adopting a Revivalist approach that includes Neo-romanticism, Neo-Gothic, Neo-Manueline and Neo-Moorish. The overall impression is of a medieval castle. The building's most striking feature is the tower, the base of which juts out into a small cove.

In 1910 the house was sold to the 1st Count of Castro Guimarães who, with his wife, lived there until his death in 1927. He donated the house and its garden to the state.

| ✉ **Addr:** | Av. Rei Humberto II de Itália 7, 2750-642 Cascais | ⚲ **Where:** | 38.691656 -9.421561 |
| --- | --- | --- | --- |
| ❓ **What:** | Museum | ⏲ **When:** | Morning |
| 👁 **Look:** | North | Ⓦ **Wik:** | Condes_de_Castro_Guimarães_Museum |

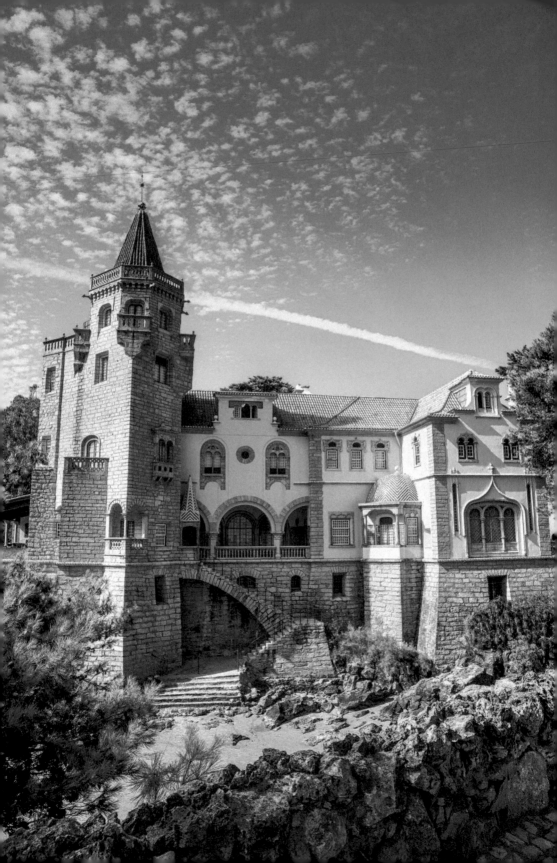

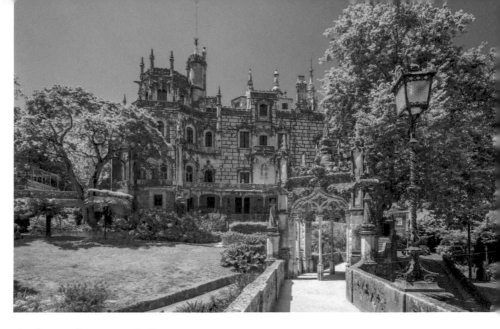

## Quinta da Regaleira is a romantic and evocative estate near Sintra, boasting numerous architectural styles, mysterious symbolism and an enigmatic system of tunnels.

The luxurious grounds feature caves and grottoes, underground walkways, cavernous wells, lush parkland, spectacular fountains, and numerous waterfalls and lakes.

Explore the five-story palace flanked by pinnacles and gargoyles, the frescoe-embellished chapel hearkening back to the Knights Templar, a deep subterranean tower well featuring Tarot and masonic mysticism, and deliciously-named sites such as Leda's Cave, the Gods Promenade, and the Portal of the Guardians. A feast for photographers!.

| ✉ **Addr:** | R. Barbosa do Bocage 5, 2710-567 Sintra | ♀ **Where:** | 38.7961698 -9.3958293 |
| --- | --- | --- | --- |
| ❓ **What:** | Building | ⏱ **When:** | Morning |
| 👁 **Look:** | Northwest | W **Wik:** | Quinta_da_Regaleira |

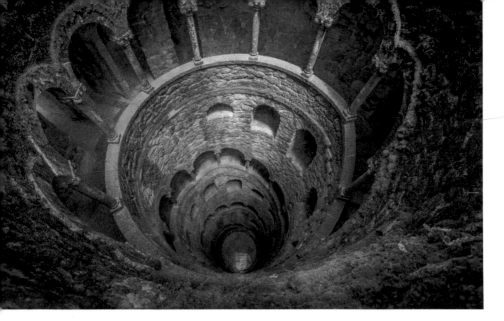

The **Initiation Well** (Poço Iniciático) at Quinta da Regaleira is one of the photographic highlights of Lisbon. This inverted tower (or iniciatic well) descends 27 m (88 feet) into the ground and was built and used for ceremonial purposes that included Tarot initiation rites. The moss-covered stone walls contain a spiral staircase with several small landings. The spacing of these landings, combined with the number of steps in the stairs, are linked to Tarot mysticism.

At the bottom, tunnels run the length of the gardens and connect to a second well, the "unfinished well."

Because lighting is so tricky in a deep hole, try using the HDR (High Dynamic Range) setting of your camera to take several images at different exposures and combine them into one cool picture.

| ✉ **Addr:** | R. Barbosa do Bocage 9, 2710-567 Sintra | ♀ **Where:** | 38.794571 -9.396891 |
| --- | --- | --- | --- |
| ❓ **What:** | Well | ◑ **When:** | Anytime |
| 👁 **Look:** | North | Ⓦ **Wik:** | Quinta_da_Regaleira#Initiation_Wells |

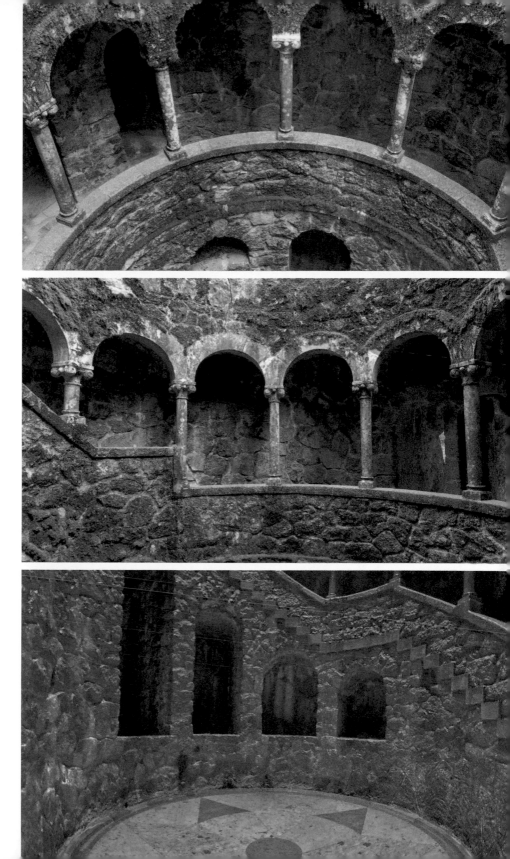

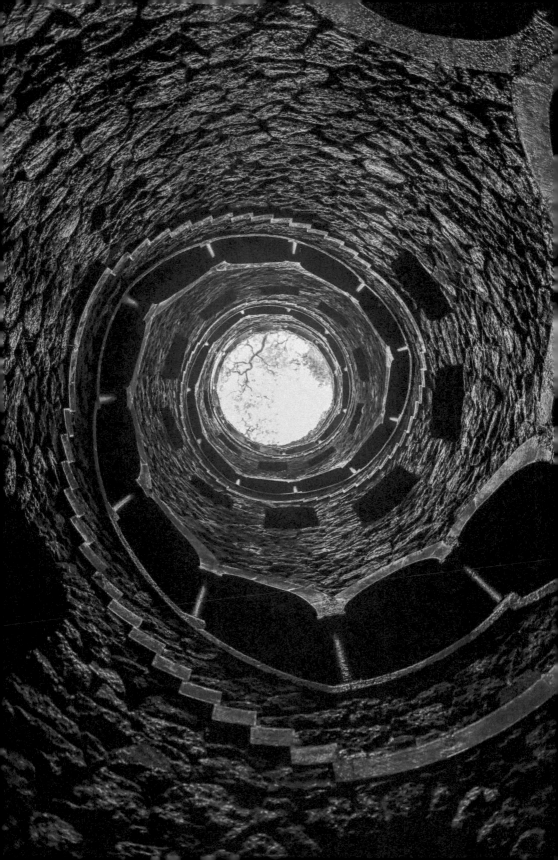

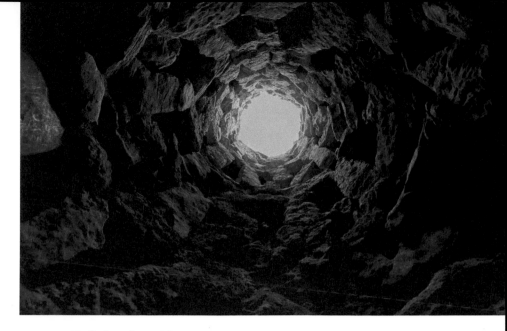

The **Unfinished Well** is a smaller initiation well. There are straight stairs that connect a series of ring-shaped floors to one another.

| ✉ **Addr:** | R. Barbosa do Bocage 5, 2710-567 Sintra | ♀ **Where:** | 38.79521 -9.39699 |
|---|---|---|---|
| ❷ **What:** | Well | ◐ **When:** | Anytime |
| 👁 **Look:** | North | ↔ **Far:** | 0 m (0 feet) |

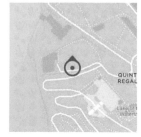

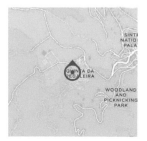

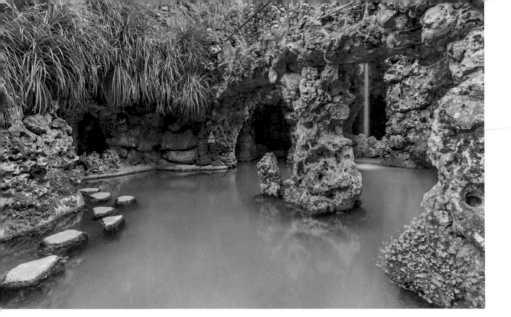

**Waterfall Lake** in the gardens of Quinta da Regaleira is a grotto with stepping stones, approached by a tunnel. There is, as the name implies, a (man-made) waterfall.

| ✉ **Addr:** | R. Barbosa do Bocage 5, 2710-567 Sintra | ♀ **Where:** | 38.795386 -9.39596 |
|---|---|---|---|
| ❷ **What:** | Grotto | ◐ **When:** | Afternoon |
| 👁 **Look:** | North | ↔ **Far:** | 0 m (0 feet) |

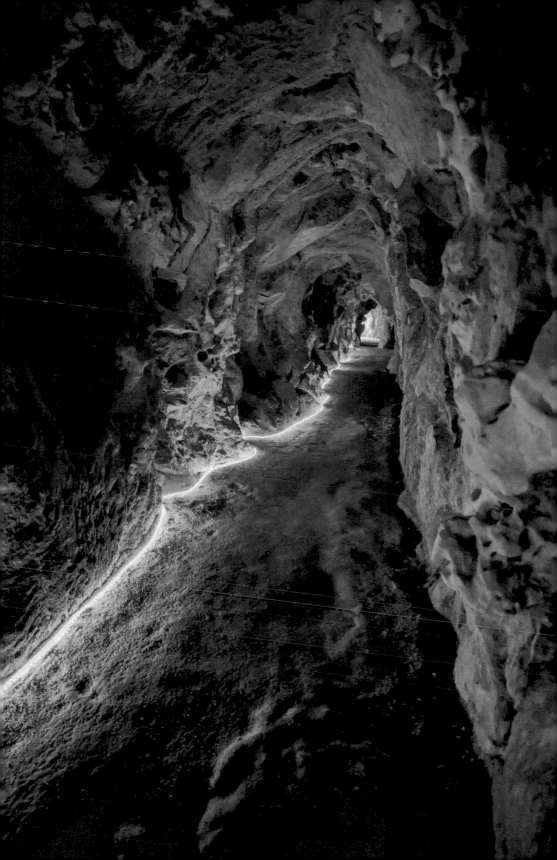

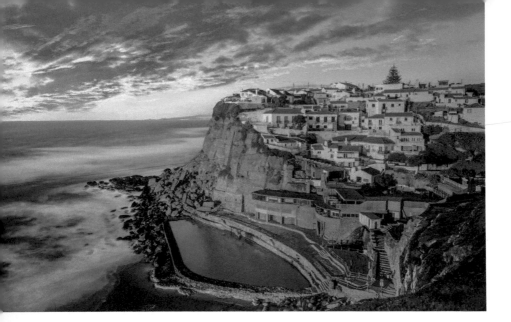

**Azenhas do Mar** is a seaside town in the municipality of Sintra. This view of the main beach and the tidal pool is taken at sunset from the observation deck of Seaview Place.

| ✉ **Addr:** | Escadinhas J. Ramos Baeta 14, 2705-101 Colares | ♀ **Where:** | 38.839829 -9.463091 |
| --- | --- | --- | --- |
| ❓ **What:** | Beach | ◐ **When:** | Sunset |
| 👁 **Look:** | Northeast | ↔ **Far:** | 110 m (340 feet) |

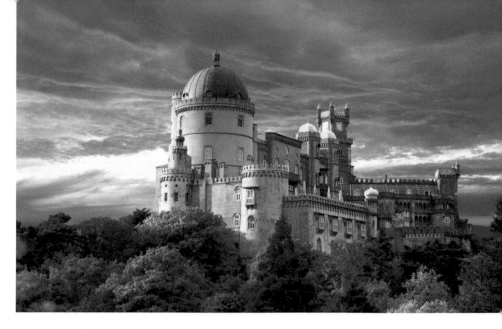

**Pena Palace** (Palácio da Pena) is a Romanticist castle above the town of Sintra. On a clear day it can be easily seen from Lisbon and much of its metropolitan area. It is a national monument and constitutes one of the major expressions of 19th-century Romanticism in the world. The palace is a UNESCO World Heritage Site and one of the Seven Wonders of Portugal.

In 1838, King consort Ferdinand II converted an old monastery into a Romantic style summer residence for the Portuguese royal family. Constructed mainly 1842–1847 by German mining engineer Wilhelm Ludwig von Eschwege, Pena Palace has an intentional mixture of eclectic styles includes the Neo-Gothic, Neo-Manueline, Neo-Islamic and Neo-Renaissance.

| ✉ **Addr:** | Estrada da Pena, 2710-609 Sintra | ♀ **Where:** | 38.78778 -9.39056 | |
| --- | --- | --- | --- | --- |
| ❓ **What:** | Castle | ◐ **When:** | Sunset | |
| 👁 **Look:** | North | W **Wik:** | Pena_Palace | |

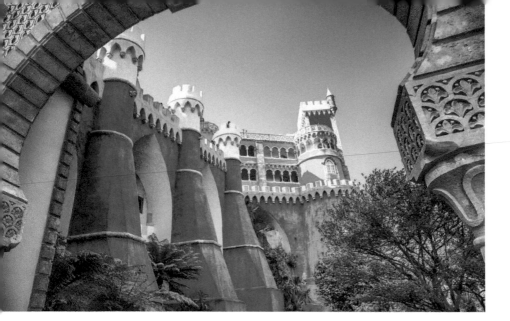

The **first entrance arch** provides a Moorish frame of the huge buttresses supporting the north tower. The second entrance arch (not pictured) has a drawbridge. Above both arches is a bridge with a good view of the front facade of the palace.

| ✉ **Addr:** | | 📍 **Where:** | 38.787408 -9.390269 | |
|---|---|---|---|---|
| 🕐 **When:** | Afternoon | 👁 **Look:** | North | |
| ↔ **Far:** | 40 m (130 feet) | | | |

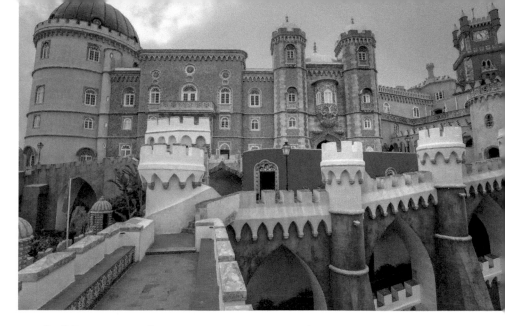

The **bridge over the two entrance arches** provides a good view of the palace's front facade.

| ✉ **Addr:** | | 📍 **Where:** | 38.787423 -9.390236 | |
|---|---|---|---|---|
| ◑ **When:** | Morning | 👁 **Look:** | West-northwest | |
| ↔ **Far:** | 30 m (110 feet) | | | |

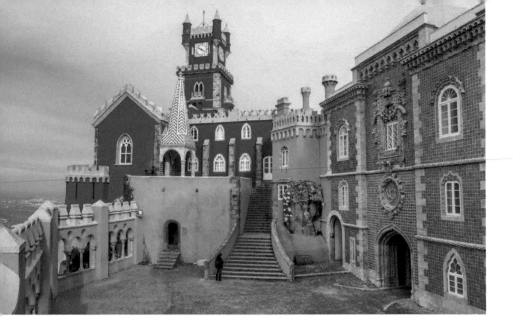

**Arches Yard** is the a plaza at the rear of the palace, with colorful views of the chapel and clock tower.

| ✉ **Addr:** | | 📍 **Where:** | 38.787600<br>-9.390759 |
|---|---|---|---|
| ❓ **What:** | Courtyard | 🌓 **When:** | Afternoon |
| 👁 **Look:** | Northeast | ↔ **Far:** | 40 m (110 feet) |

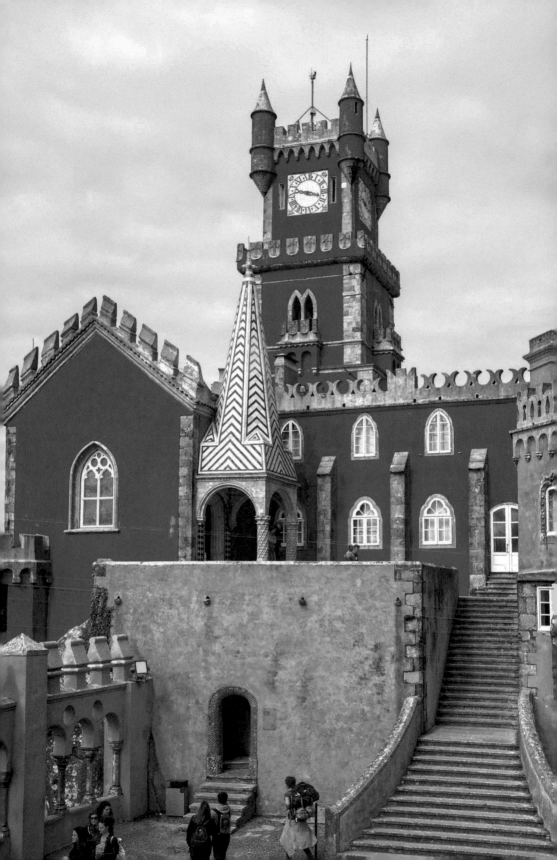

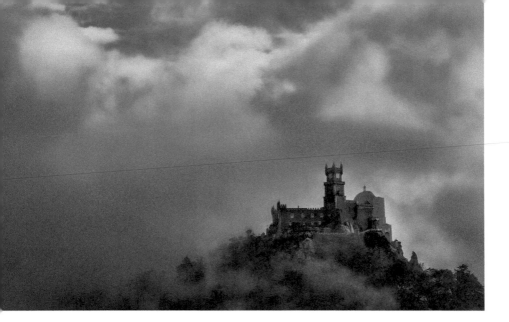

The view of Pena Palace from **Castle of the Moors** shows the northern side, painted entirely in red.

| ✉ **Addr:** | | ♀ **Where:** | 38.791966 -9.389448 | |
| --- | --- | --- | --- | --- |
| ☾ **When:** | Morning | ◉ **Look:** | South | |
| ↔ **Far:** | 470 m (1540 feet) | | | |

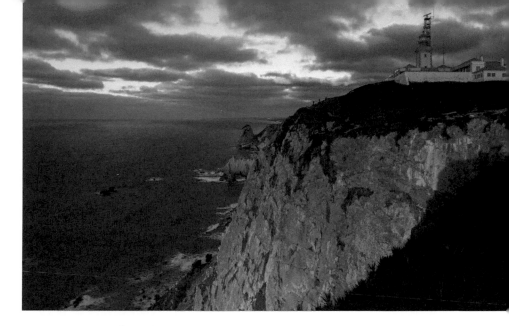

## Cape Roca Lighthouse (Farol do Cabo da Roca) is perched at the westernmost point of mainland Portugal, continental Europe and the Eurasian land mass.

Cabo da Roca was known to the Romans as Promontorium Magnum, and during the Age of Sail as the Rock of Lisbon.

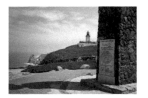

| ✉ **Addr:** | Colares, Portugal | ♀ **Where:** | 38.780777 -9.498673 |
| ❓ **What:** | Lighthouse | ◑ **When:** | Sunset |
| 👁 **Look:** | Northeast | W **Wik:** | Cabo_da_Roca |

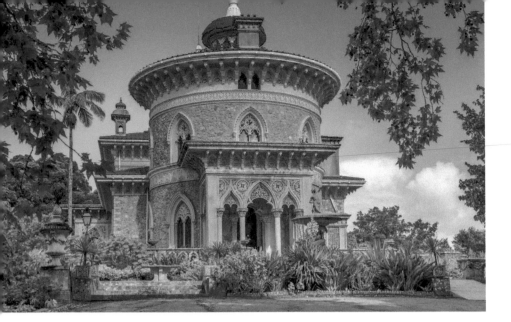

**Monserrate Palace** (Palácio de Monserrate) is a palatial villa located near Sintra, the traditional summer resort of the Portuguese court. Francis Cook, a wealthy English merchant, purchased the property in 1863 and built this summer residence of his family.

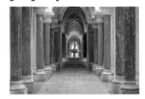

The design by James Knowles was influenced by Romanticism and Mudéjar Moorish Revival architecture with Neo-Gothic elements. The eclecticism is a fine example of the Sintra Romanticism.

The lush garden is designed in a romantic style with a lake, fountains and grottoes.

| ✉ **Addr:** | Palácio de Monserrate, 2710-405 Sintra | ♀ **Where:** | 38.793928 -9.420273 |
|---|---|---|---|
| ❓ **What:** | Palace | ☽ **When:** | Morning |
| 👁 **Look:** | Northwest | W **Wik:** | Monserrate_Palace |

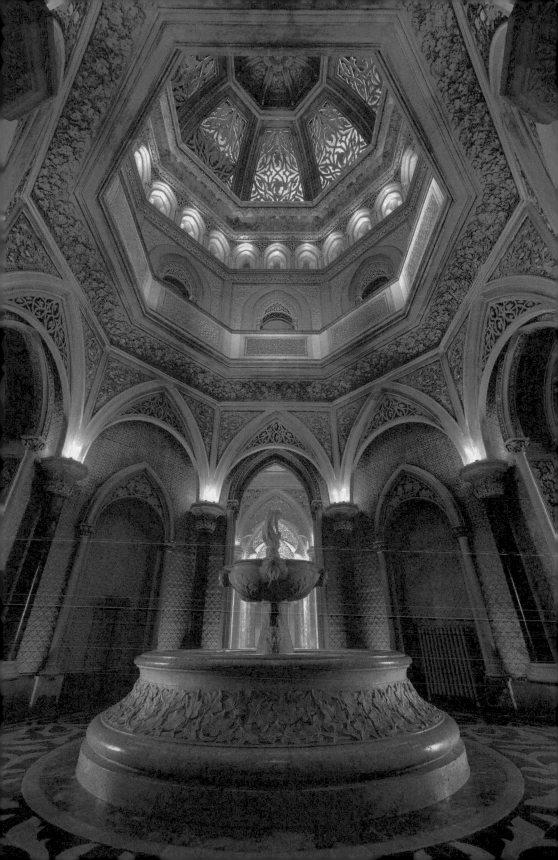

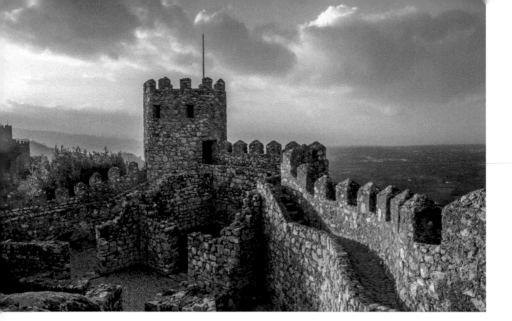

## Castle of the Moors (Castelo dos Mouros) is a hilltop medieval castle located in Sintra, about 25km northwest of Lisbon.

Built by the Moors in the 8th and 9th centuries, it was an important strategic point during the Reconquista, and was taken by Christian forces after the fall of Lisbon in 1147. It is part of the Sintra Cultural Landscape, a UNESCO World Heritage Site.

| ✉ **Addr:** | Estrada da Pena 12, 2710 Sintra | ♀ **Where:** | 38.793053 -9.388733 |
| --- | --- | --- | --- |
| ❷ **What:** | Castle | ◑ **When:** | Morning |
| 👁 **Look:** | West | W **Wik:** | Castle_of_the_Moors |

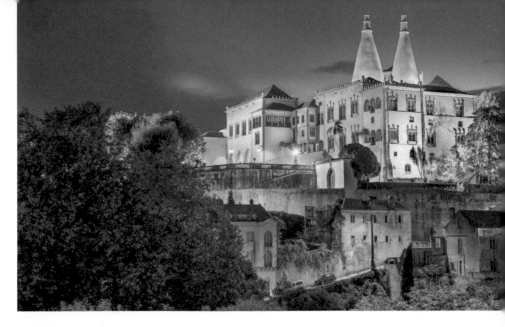

**Sintra National Palace** is the best-preserved medieval royal residence in Portugal, being inhabited more or less continuously from at least the early 15th century to the late 19th century. It is a significant tourist attraction, and is part of the cultural landscape of Sintra, a designated UNESCO World Heritage site.

| ✉ **Addr:** | Largo Rainha Dona Amélia, 2710-616 Sintra | ♀ **Where:** | 38.7976223 -9.3879736 |
| --- | --- | --- | --- |
| ❓ **What:** | Palace | ◑ **When:** | Anytime |
| 👁 **Look:** | West | W **Wik:** | Sintra_National_Palace |

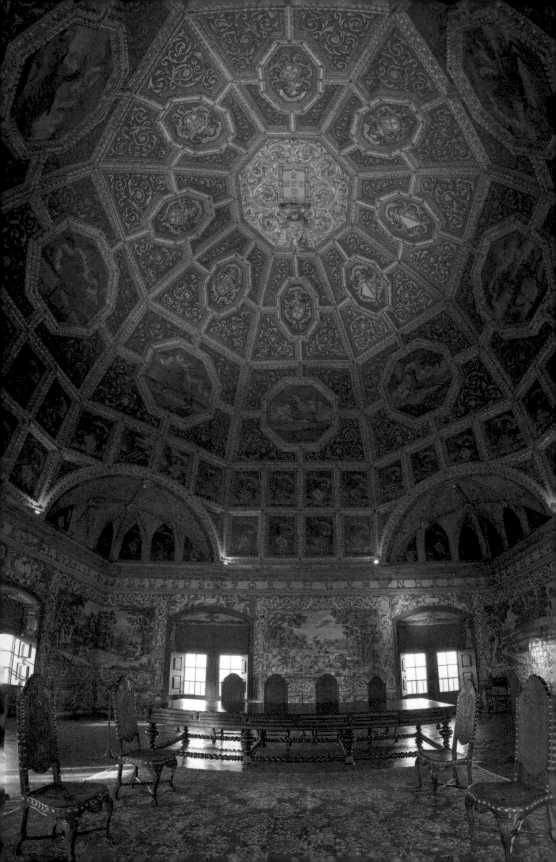

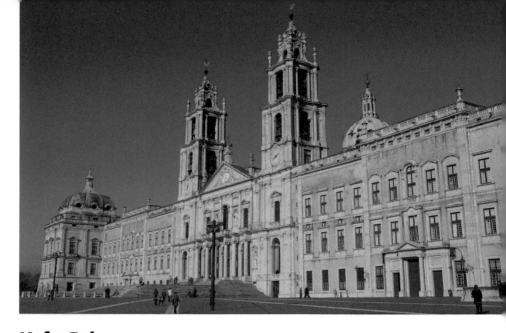

## Mafra Palace

**Mafra Palace** (Palácio de Mafra, also Mafra National Palace, Palácio Nacional de Mafra) is among the most sumptuous Baroque buildings in Portugal and one of the largest royal palaces. The main facade is 220 m (720 feet) long.

Construction began in 1717 as a monastery for 13 Capuchin friars, after King John V (1707–1750) vowed to build a convent if his wife gave him offspring. But with gold flowing in from the Portuguese colony of Brazil, and a location near the king's game preserve, plans changed. The construction swelled to 45,000 workers, plus 7,000 soldiers to preserve order. The whole complex has about 1,200 rooms and 156 stairways.

Photographic highlights include the library and the basilica.

| ✉ **Addr:** | Terreiro D. João V, Mafra | ♀ **Where:** | 38.9361 -9.327323 |
| --- | --- | --- | --- |
| ❓ **What:** | Palace | ◑ **When:** | Afternoon |
| 👁 **Look:** | North-northeast | W **Wik:** | Palace_of_Mafra |

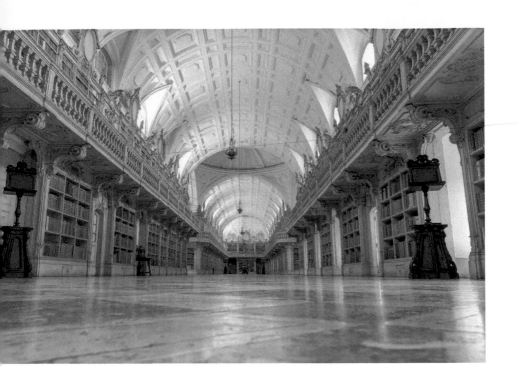

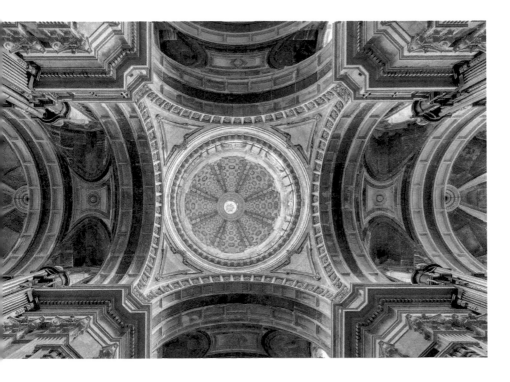

# QR codes

**Each location** includes a QR code which you can scan to show the GPS spot on your smartphone.

A QR code (for **Quick Response** code) is a two-dimensional barcode which stores text — in our case, GPS coordinates. When scanned, the data will be recognized as a location and be passed to a map app. Typically, the map will center on this spot and highlight it with a marker.

Using a QR code is like taking a photo — just point and shoot. Then tap to see the location on your map app.

## How to use QR codes

1. 👍 **Get an app**
   You may need an app to scan a QR code. There are many free apps; search for "QR reader". I like **QR Code Reader** and **Quick Scan** (both are free).
2. 👍 **Scan the QR code**
   Point your smartphone's camera at the QR code. When the camera has the QR code in focus, the app will automatically scan it.
3. 👍 **Tap to map**
   Depending on the app, you will either be taken immediately to your map app, or be given an option to do so. (Note: GPS locations are approximate so use prudence.)

#  Credits

**Thank you** to the many wonderful people and companies that made their work available to use in this guide.

Photo key: The number is the page number. The letters reference the position on the page, the distributor and the license. Key: a:CC-BY-SA; b:bottom; c:center; d:CC-BY-ND; e:CC-PD; f:Flickr; h:Shutterstock standard license; l:public domain; s:Shutterstock; t:top; w:Wikipedia; y:CC-BY.

Cover image by Sean Pavone/Shutterstock. Back cover image by Sean Pavone/Shutterstock. Acaro (163 wa); Nol Aders (95 sh); Alexilena (155 sh); Alredosaz (137t wa); Alvesgaspar (47, 58t sh); Arkanto (90 fy); Paul Arps (67t sh); Pavel Arzhakov (108t sh); Ungvari Attila (32t, 61 sh); Awp76 (147t, 148, 158t sh); Salvador Aznar (94t wa); Reino Baptista (76 wa); Harvey Barrison (135 sh); Yasemin Olgunoz Berber (51t sh); Radu Bercan (102t, 113 sh); Goncalo Borba (29t sh); Cherkasov (104t sh); Peek Creative Collective (57t sh); John Copland (169t sh); Marco Crupi (51, 53t wy); Bosc D'anjou (96 sh); Dimbar76 (42t fa); Maria Eklind (33t sh); Shchipkova Elena (69t sh); Positive Emotions (75t sh); Rob Van Esch (54 sh); Expose (92t, 92 fa); Mark Fischer (78t sh); Nessa Gnatoush (49 sh); Andre Goncalves (29b sh); Farbregas Hareluya (54t sh); Hidalgo (78 sh); Homydesign (152 sh); Nido Huebl (97t, 117, 118t, 127 wa); Husond (136t sh); Illpaxphotomatic (133 sh); Zabotnova Inna (99, 117t, 118, 121t, 123 sh); Jelome (106 sh); Ritu Manoj Jethani (125t sh); Jiawangkun (83t wa); Juntas (131t, 133t wa); Paulo Juntas (131 sh); Zoran Karapancev (66t, 67b sh); Karnizz (41b sh); Kavalenkava (38t, 59t, 60t, 62t, 63 fe); Terry Kearney (138t sh); Karan Khurana (64t wy); Felix König (45 sh); Kraft_stoff (168 sh); Krivinis (72t, 73 sh); Ingus Kruklitis (115t sh); Marcin Krzyzak (79 sh); Mateusz Kurzyk (112 sh); Kvika (98t wa); Lacobrigo (46t, 105 sh); Lattasit Laohasiriwong (166t sh); Martin Lehmann (135t sh); Lensfield (101 sh); Leoks (160t sh); Elijah Lovkoff (82t, 84, 126t wa); Lrocha (89t sh); Lucvi (28c, 28b, 30t, 119t sh); Aron M (50t wa); Maria Eklind (34 sh); Eugenio Marongiu (33 sh); Marques (74 sh); Andres Garcia Martin (35 sh); Benny Marty (43t, 60b, 124t, 145, 154 sh); Nicola Messana (55 sh); Milosk50 (96t, 127t sh); Monteiro (104b sh); Mr.c (86 sh); Narcisopa (83 sh); Nataliya Nazarova (72 wa); Susanne Nilsson (34t wy); Olga1969 (163t wy); Vitor Oliveira (166 sh); Onajourney (106t fy); Travelholic Path (40t sh); Paulzhuk (109 sh); Sean Pavone (81t, 164t, 164, 167t wy); Pedro (139t wa); Peter (116t sh); Vadim Petrakov (114t sh); Vlada Photo (61t sh); Photoshooter2015 (125b sh); Plusone (81c fy); Pravin.premkumar (71t sh); Esb Professional (28t, 62, 80t sh); Ribeiroantonio (81b, 89 sh); Icardo Rocha (107 sh); Helen Ross (129t wy); Bernt Rostad (88 sh); Alexandre Rotenberg (142t, 143t, 146t sh); Rrrainbow (56t, 70t, 77t sh); Pere Rubi (64 sh); Robin Runck (44t sh); S-f (63t, 65, 134t, 141t, 142 sh); Saiko3p (85 sh); Alfredo Garcia Saz (170t, 170b wa); Scalleja (93t sh); Sck_photo (130 wy); Shadowgate (30b, 31, 121 sh); Silky (52t sh); Bruno Pereira da Silva (144t wy); Xiquinho Silva (32 fy); Pedro Ribeiro Simões (98 sh); Stephan Smit (165 sh); Jose Ignacio Soto (140t, 140b, 151t, 151c sh); Rolf E. Staerk (158, 162t sh); Vladimir Staykov (111t sh); Stefano_valeri (41t, 149t sh); Stella Photography (137 sh); Steve Photography (42 wa); Stijndon (151b sh); Billy Stock (105t sh); Lal's Stock (48t, 150t sh); Stockphotosart (49t sh); Boris Stroujko (57, 159t, 160 sh); Suronin (103t wl); Swissbert (68t sh); Adam Szuly (122t sh); Taiga (157t sh); Kuryanovich Tatsiana (132 sh); Val Thoermer (87t, 119, 128 sh); Travelview (43t sh); Ttstudio (22, 29c, 74t sh); Tupungato (129 sh); Yuri Turkov (161 fd); Ulrika (108 sh); Maxim Usov (120 sh); Jorge Rodriguez Veiga (100t wa); Velvet (91t fy); Marco Verch (134 sh); Vichie81 (36 sh); Daniel Vine Photography (25

sh); Dennis Van de Water (40b, 71b, 110t sh); Yasonya (84t sh); Arkady Zakharov (88t sh); Serg Zastavkin (69b, 90t, 153t wy); Christine Zenino (113t, 115 sh); Paulo Zimmermann (156t sh); Adam Zoltan (154t sh).

Some text adapted from Wikipedia and its contributors, used and modified under Creative Commons Attribution-ShareAlike (CC-BY-SA) license. Map data from OpenStreetMap and its contributors, used under the Open Data Commons Open Database License (ODbL).

This book would not exist without the love and contribution of my wonderful wife, Jennie. Thank you for all your ideas, support and sacrifice to make this a reality. Hello to our terrific kids, Redford and Roxy.

Thanks to the many people who have helped PhotoSecrets along the way, including: Bob Krist, who answered a cold call and wrote the perfect foreword before, with his wife Peggy, becoming good friends; Barry Kohn, my tax accountant; SM Jang and Jay Koo at Doosan, my first printer; Greg Lee at Imago, printer of my coffe-table books; contributors to PHP, WordPress and Stack Exchange; mentors at SCORE San Diego; Janara Bahramzi at USE Credit Union; family and friends in Redditch, Oxford, Bristol, Coventry, Cornwall, Philadelphia and San Diego.

Thanks to everyone at distributor National Book Network (NBN) for always being enthusiastic, encouraging and professional, including: Jason Brockwell (who suggested Lisbon), Jed Lyons, Kalen Landow (marketing guru), Spencer Gale (sales king), Vicki Funk, Karen Mattscheck, Kathy Stine, Mary Lou Black, Omuni Barnes, Ed Lyons, Sheila Burnett, Max Phelps and Les Petriw. A special remembrance thanks to Miriam Bass who took the time to visit with me and sign me to NBN mainly on belief.

The biggest credit goes to you, the reader. Thank you for (hopefully) buying this book and allowing me to do this fun work. I hope you take lots of great photos!

# ∷ Index

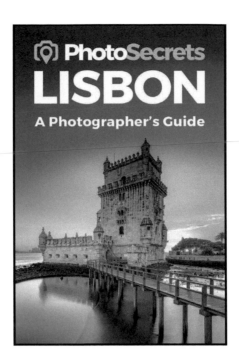

"Tips to make that perfect picture on your next trip."
— National Geographic Traveler

A "photographer's dream."
— San Jose Mercury News

"Detailed maps on where and when to capture the best and most unique shots."
— Endless Vacation

"You'll learn a lot about photography, even if you're just an armchair traveler."
— Family Photo